Eugène Atget's Paris

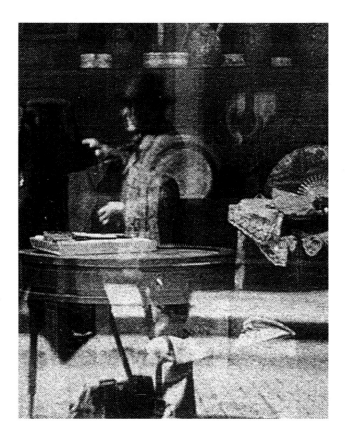

EUGÈNE ATGET
Autoportrait | Self-portrait | Selbstporträt,
Détail de | detail from | Detail aus:
Boutique empire, rue du
Faubourg-Saint-Honoré, 1902

Eugène

Atget's

ESSAY BY
Andreas Krase

Paris

EDITED BY
Hans Christian Adam

TASCHEN

HONG KONG KÖLN LONDON LOS ANGELES MADRID PARIS TOKYO

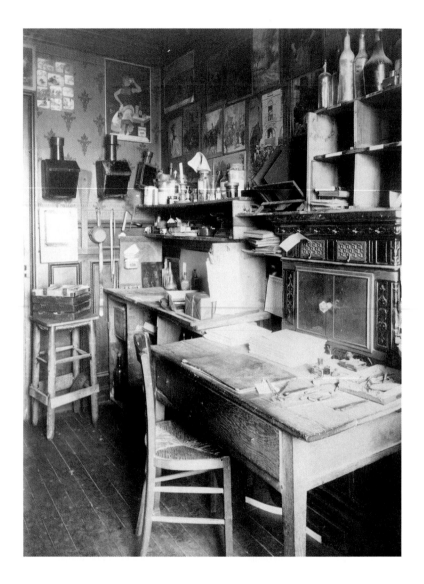

EUGÈNE ATGET
Cabinet de travail du photographe, c. 1910
The Photographer's Studio
Das Arbeitszimmer des Photographen

SOMMAIRE
CONTENTS
INHALT

INTRODUCTION EINLEITUNG
 ANDREAS KRASE
20 - 24| Archives du regard
 Inventaire des choses
 Le Paris d'Eugène Atget

25 - 29| Archive of Visions
 Inventory of Things
 Eugène Atget's Paris

30 - 34| Archiv der Blicke
 Inventar der Dinge
 Eugène Atgets Paris

PLANCHES PLATES TAFELN

8 - 19| Portfolio Eugène Atget

36 - 45| Les Petits Métiers de Paris
 Salesmen and Traders on the
 Streets of Paris
 Gewerbetreibende und Händler auf
 den Straßen von Paris

46 - 89| Le Vieux Paris
 Old Paris| Das Alte Paris

90 - 95| Escaliers | Stairs| Treppen

96 - 105| Intérieurs parisiens
 Paris Interiors| Paris Interieurs

106 - 127| Métiers, boutiques et étalages
 Trades, Shops and Window-Displays
 Gewerbe, Läden und Schaufenster-
 auslagen

128 - 135| La Voiture à Paris | Vehicles in Paris
 Fahrzeuge in Paris

136 - 141| Zoniers de Paris
 The Inhabitants of the Paris Shanty-
 Towns
 Bewohner der Pariser Außenbezirke

142 - 147| Maison close | House of pleasure
 Freudenhaus

148 - 157| Fêtes foraines| Fairs| Jahrmärkte

158 - 165| Les Environs de Paris
 The Outskirts of Paris
 Die nahe Umgebung von Paris

166 - 177| Jardins et châteaux
 Parks and Castles
 Gärten und Schlösser

ANNEXES APPENDIX ANHANG

178| Biographie | Biography

190| Crédits photographiques
 Photographic credits
 Bildnachweis

191| Légendes du portfolio
 Portfolio captions
 Portfolio Bildlegenden

« On se souviendra de lui comme d'un historien de l'urbanisme, d'un véritable romantique, d'un amoureux de Paris, d'un Balzac de la caméra, dont l'œuvre nous permet de tisser une vaste tapisserie de la civilisation française. »

" He will be remembered as an urbanist historian, a genuine romanticist, a lover of Paris, a Balzac of the camera, from whose work we can weave a large tapestry of French civilization."

„ Er wird uns in Erinnerung bleiben als Stadthistoriker, wahrer Romantiker, Liebhaber der Stadt Paris und Balzac der Kamera, dessen Arbeiten sich wie die Fäden einer Tapisserie zu einem großen Bild der französischen Kultur zusammenfügen."

BERENICE ABBOTT

LE PARIS D'EUGÈNE ATGET
EUGÈNE ATGET'S PARIS
EUGÈNE ATGETS PARIS

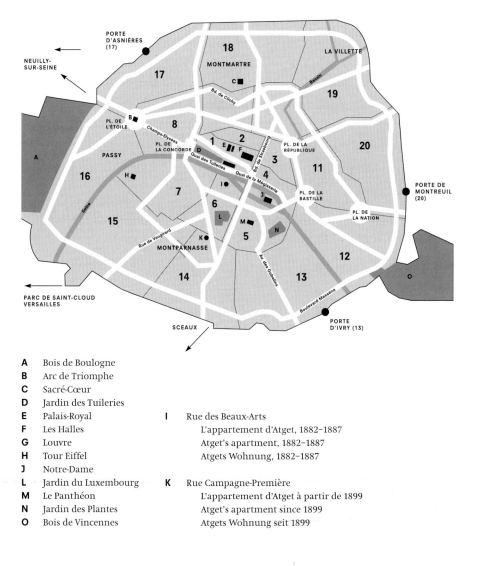

A Bois de Boulogne
B Arc de Triomphe
C Sacré-Cœur
D Jardin des Tuileries
E Palais-Royal
F Les Halles **I** Rue des Beaux-Arts
G Louvre L'appartement d'Atget, 1882–1887
H Tour Eiffel Atget's apartment, 1882–1887
J Notre-Dame Atgets Wohnung, 1882–1887
L Jardin du Luxembourg
M Le Panthéon **K** Rue Campagne-Première
N Jardin des Plantes L'appartement d'Atget à partir de 1899
O Bois de Vincennes Atget's apartment since 1899
 Atgets Wohnung seit 1899

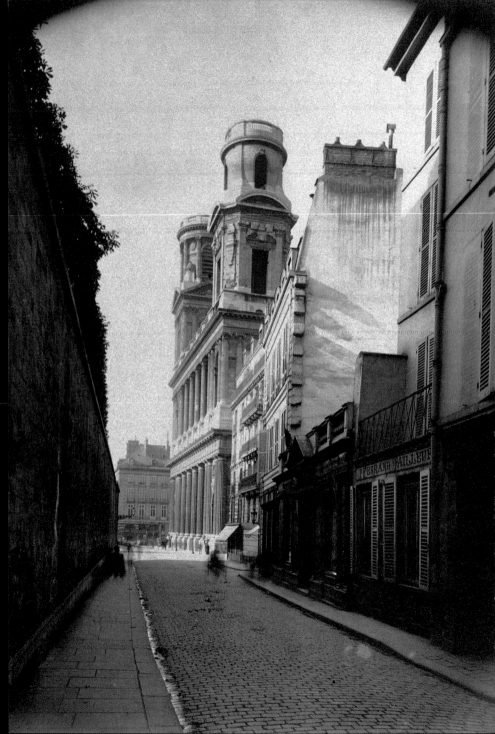

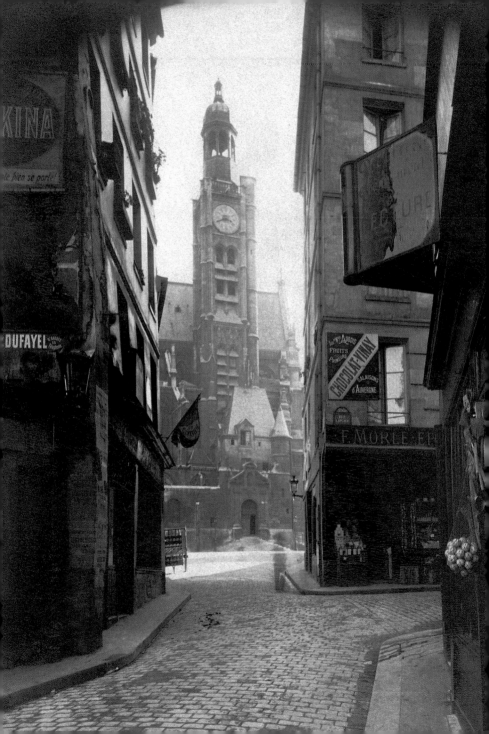

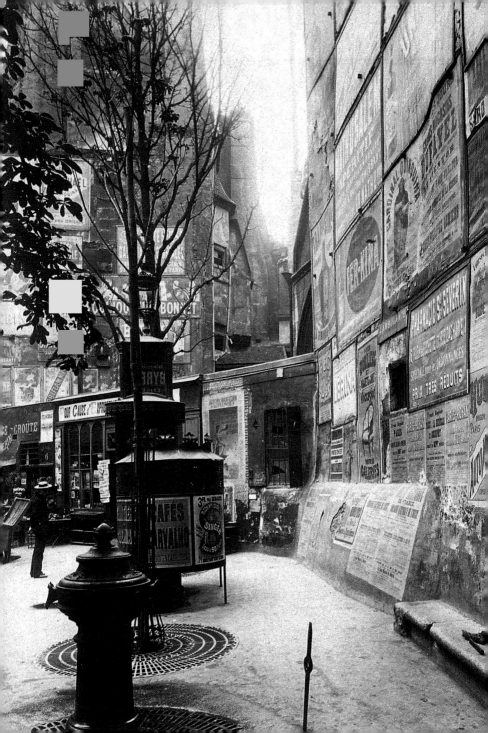

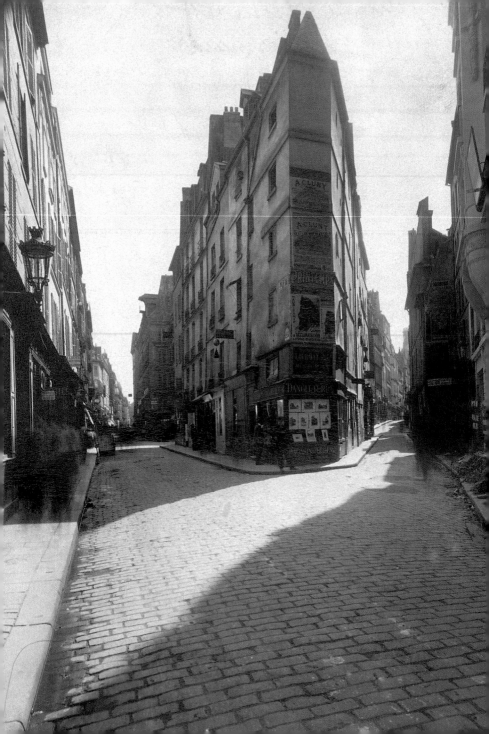

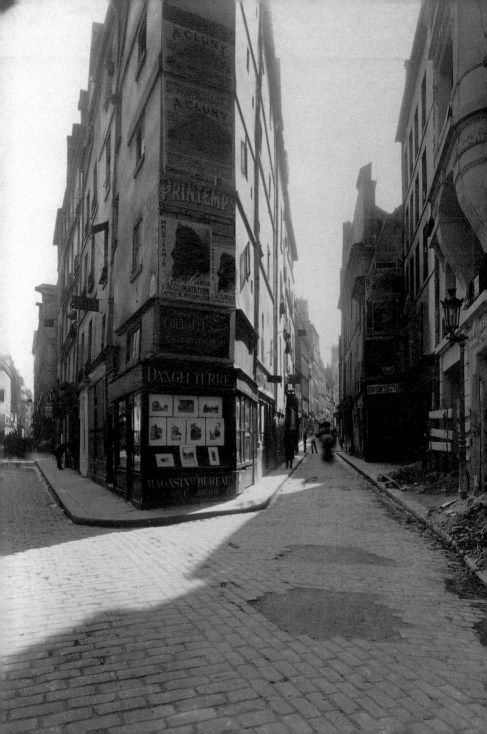

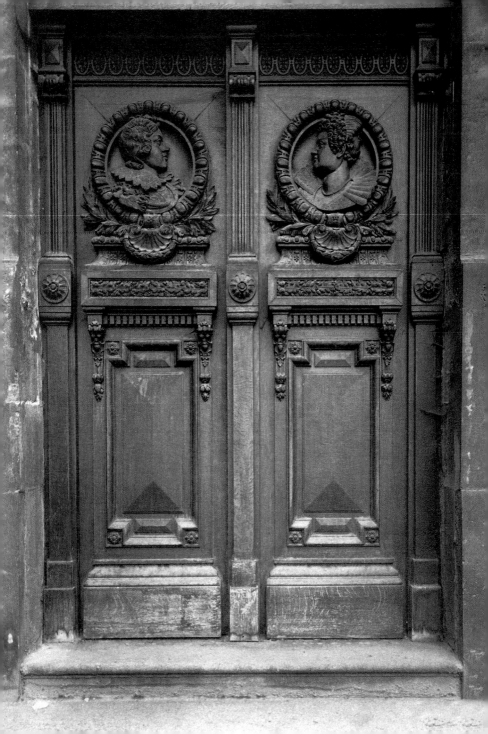

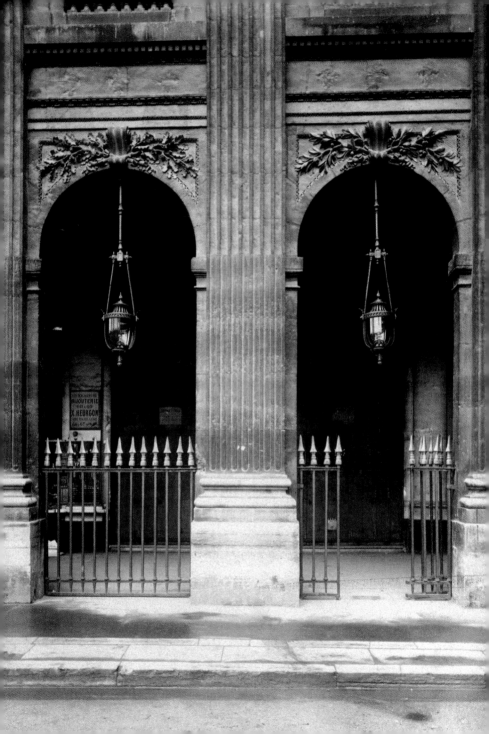

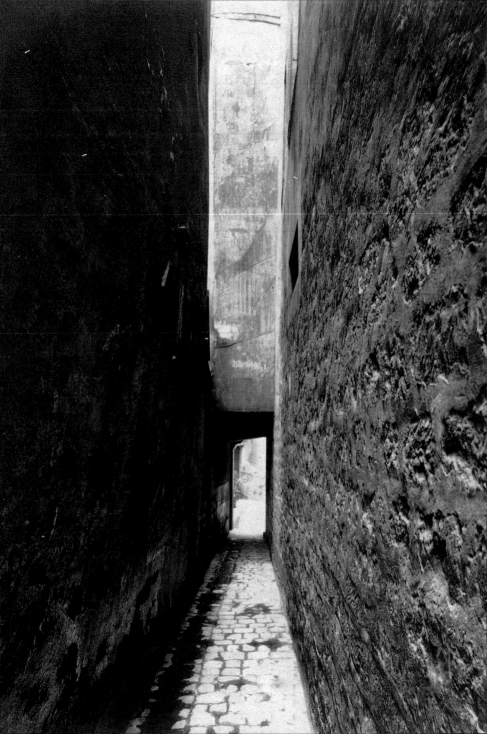

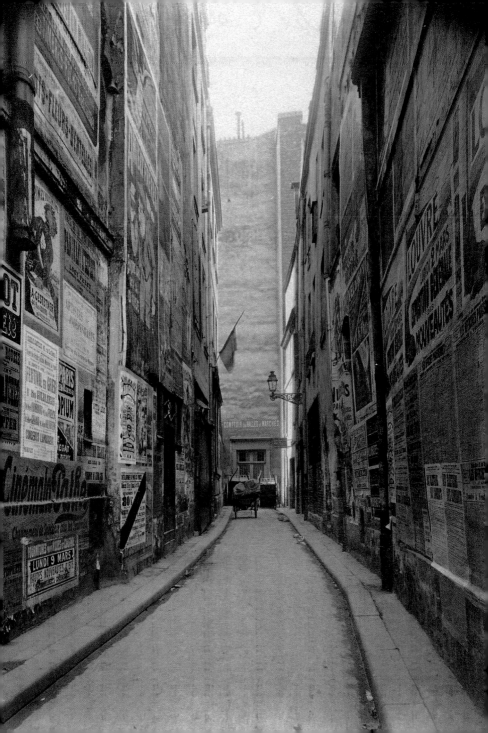

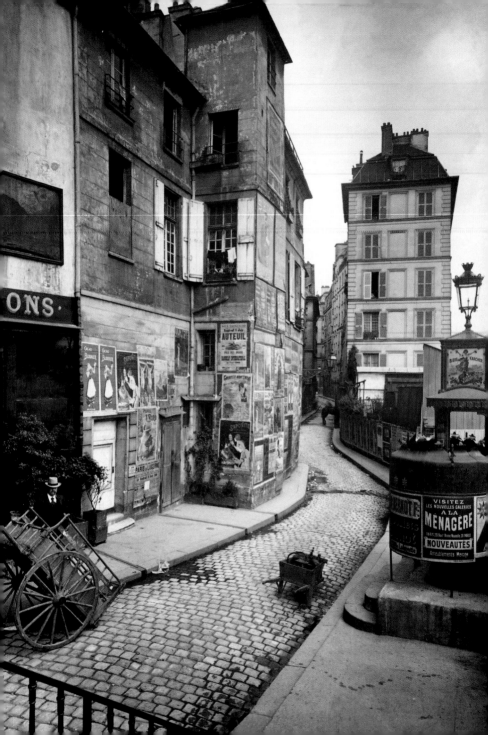

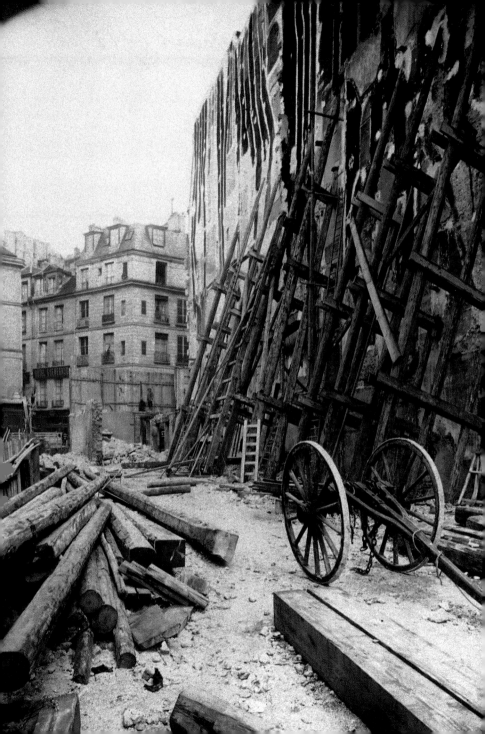

ANDREAS KRASE

Archives du regard
Inventaire des choses
Le Paris d'Eugène Atget

Eugène Atget était *le* photographe du Vieux Paris. Entre 1897 et 1927, il a su fixer comme personne les empreintes de l'Histoire dans ses images. C'était son ouvrage quotidien, sa profession, mais aussi sa vocation que de suivre avec son appareil les transformations de la ville. Son enterrement en août 1927 passa pratiquement inaperçu. Aujourd'hui, Atget compte en revanche comme une des personnalités majeures de l'histoire de la photographie. Son œuvre est considérée comme une passerelle entre la photographie topographique du 19e siècle et le «documentarisme artistique» du 20e siècle. Au-delà de leur thématique, ses images peuvent être vues comme les témoignages d'une passion, d'un absolu du visuel auquel la perfection technique importait peu, mais pour lequel l'espace iconique en tant que vecteur de perception était tout.

Les photos d'Atget montrent Paris sous différentes facettes : les rues étroites et encaissées du centre historique avec leurs vieux édifices et leurs somptueux hôtels particuliers d'avant la Révolution, les places, les ponts et les quais de la Seine. Il a photographié des devantures de magasins et des enseignes de restaurants, pénétré avec son appareil des cours et des cages d'escalier, pris des détails de façades et fixé l'aménagement intérieur de plusieurs immeubles. Mais les camelots, les petits artisans, les chiffonniers et enfin les prostituées des banlieues pauvres lui servirent eux aussi de modèles. Il se tourna avec un intérêt particulier vers les fêtes foraines et les kermesses des différentes circonscriptions de Paris, dont il fixa sur ses plaques les décors fan-

tastiques. Mais le Paris d'Eugène Atget englobe également les environs, les parcs de Versailles, de Saint-Cloud et de Sceaux, ainsi que les zones de transition avec la périphérie villageoise.

Eugène Atget (1857-1927) avait déjà dans les trente-cinq ans lorsqu'il devint photographe. Il avait abandonné sa carrière de comédien dans divers théâtres de province et pendant un certain temps, il avait essayé, mais en vain, de gagner sa vie comme peintre. « Documents pour artistes », telle était l'inscription du petit panneau qu'il avait placardé vers 1892 sur sa porte. En effet, il proposait surtout des clichés qui pouvaient servir de modèles à des artistes et des artisans d'art.

A partir de 1898, Atget commença à photographier systématiquement les témoignages architecturaux de l'époque antérieure à 1789, c'est-à-dire ce qu'on appelle « le Vieux Paris ». Cette année-là, la Commission du Vieux Paris, dont l'objectif consistait à faire converger les efforts entrepris jusqu'ici en matière d'étude et de documentation du Paris historique et ceux qui visaient à protéger les monuments, s'était réunie sur décision du conseil municipal de Paris. Le sentiment de se trouver au tournant d'une époque, avec tout l'intérêt pour le passé et la nostalgie que cela sous-entend, s'est sans doute cristallisé à Paris comme dans aucune autre ville d'Europe. L'instigateur de la restructuration de la ville, le baron Haussmann, s'était lui-même efforcé, en tant que fondateur d'une commission municipale, le Service des travaux historiques, de faire enregistrer l'état dans lequel se trouvait la ville avant les transformations.

Atget faisait partie de ces photographes qui surent voir une chance dans cette situation. La plupart de ses acheteurs étaient à présent des institutions comme la Société d'Histoire, mais aussi des musées et des bibliothèques, ou encore les collections de modèles de certaines écoles d'art appliqué. A la différence de la plupart de ses confrères, il sut conserver son indépendance. Lui-même décidait, en règle générale, du choix des motifs qui lui semblaient susceptibles de donner lieu à reproduction et de la façon dont il voulait les voir reproduits. Son intérêt se portait sur les aperçus, les échappées, bref sur l'interprétation de constellations spatiales. Il en vint ainsi à élaborer des formules créatives qui ne craignaient pas de rompre avec les conventions. Forts

contrastes de lumière, plasticité due à la dureté des ombres et inter-férence des formes devinrent les signes caractéristiques de sa vision plastique. Des portes ouvertes devenaient l'occasion d'apercevoir des objets qu'on avait laissés là par hasard, objets qui invitaient le specta-teur à imaginer la réalité dissimulée dans ces images et en même temps, à voir dans ce qui avait été saisi par la photographie l'esquisse d'une histoire de la vie quotidienne.

On ne sait que très peu de choses des origines d'Atget, de sa for-mation et de sa vie privée, même si les Parisiens ont pu observer pen-dant des dizaines d'années ce personnage un peu bizarre arpenter les rues de leur ville pour faire des prises de vue. Bon nombre de clichés ont conservé des traces de sa présence, principalement sous la forme de reflets renvoyés par des vitres de portes ou de fenêtres. La photo-graphie *Boutique empire, rue du Faubourg Saint-Honoré* de 1902 le montre par exemple en train de travailler en tenue bourgeoise, un chapeau sur la tête. Un autre cliché célèbre de cette époque en garde lui aussi le sou-venir. Dans les reflets d'un manteau de cheminée se dessine en effet la masse sombre d'une créature flanquée de l'œil d'un objectif, comme un symbole du photographe. Un cliché du restaurant *Au Tambour* de 1908 pousse encore plus loin ce jeu de reflets. On y voit Atget, vêtu d'un manteau foncé, debout sur le côté près de son appareil, reflété dans la vitre de la porte. On peut se demander si le hasard était de la partie ou si le photographe s'est livré à la mise en scène d'un canular énigma-tique (on voit en effet flotter à l'endroit de sa tête, blafard et sans corps, le visage d'une des personnes qui se trouvent à l'intérieur, pro-bablement le patron). Ce sont des clichés comme ceux-ci qui devaient passionner les futurs spectateurs de ses photographies. Les images d'Atget témoignent d'une réalité ambiguë, que ce soit dans l'inter-pénétration de l'intérieur et de l'extérieur, ou dans l'amalgame de visa-ges qui ressemblent à des spectres et des reflets de l'environnement urbain.

Nous sommes un peu mieux renseignés sur son cadre de vie et ses conditions de travail, Atget ayant en effet photographié les pièces de son appartement dans le cadre d'une série d'intérieurs. Il vivait depuis 1899 avec sa compagne et assistante Valentine Delafosse Com-

pagnon (1847–1926) dans un appartement de trois pièces, au cinquième étage d'une maison située à Montparnasse, au 17bis de la rue Campagne-Première. Dans cette rue tranquille qui donnait sur le boulevard Raspail vivaient des artistes et des modèles connus, et bien d'autres qui ne l'étaient pas encore. Le quartier de Montparnasse était déjà devenu avant le tournant du siècle un lieu de rendez-vous d'artistes dont l'atmosphère attirait toujours plus de gens en provenance de l'étranger. Le nombre des ateliers ne cessant d'augmenter, on y construisit même des bâtiments spéciaux destinés aux artistes. C'est dans l'un de ceux-ci, édifié en 1911 dans la rue Campagne-Première, que s'installa dans les années vingt l'un des découvreurs d'Atget, Man Ray (1890–1976). Il semblerait qu'Atget se fût bien plu dans cet environnement où certains de ses voisins étaient aussi ses clients.

C'est à partir de ce moment qu'il entreprit ses excursions. Il utilisait pour ses prises de vue une chambre en bois d'un modèle assez ancien et des négatifs sur verre, courants à l'époque, de format 18 x 24 cm. Son équipement pesait en tout dans les 20 kilos. Atget transportait donc toujours cette charge avec lui, que ce soit en explorant à pied les rues du Vieux Paris, en descendant dans les bouches de métro ou en prenant les trains qui devaient le conduire en banlieue. Il avait une prédilection pour les objectifs à courte focale qui accentuent les lignes fuyantes et permettent, par rapport aux objectifs normaux, une plus grande profondeur de champ. Celle-ci répondait du reste à l'idée qu'il se faisait de la photographie, de même que l'impression de cristallisation produite parfois par la convergence des lignes à l'intérieur de l'image et la franche séparation des différents plans. Atget n'avait toutefois rien d'un perfectionniste en matière de technique. La fonction de modèles et de documents qu'il assignait à ses photographies ne le demandait pas non plus. Et le bougé dû à la longueur des temps d'exposition ou le flou qui fait que les choses et les personnes semblent flotter mystérieusement dans l'espace, ne sont pas des choses qui nuisent à ses photographies.

Vers le milieu des années vingt, Atget fut découvert par de jeunes artistes d'avant-garde. Man Ray fit une petite collection de ses photographies. Mais ce qui lui plaisait surtout, c'était ces images qui le fai-

saient un peu penser à Dada ou au surréalisme. Et il arracha à Atget l'autorisation de reproduire quelques photographies dans la revue *La Révolution surréaliste.* Voulant visiblement se protéger d'interprétations erronées, le photographe insista pour que son nom ne fût pas mentionné dans la revue, arguant du caractère documentaire de ses images (« C'est du document et rien d'autre »).

L'engagement de Berenice Abbott (1889–1991), l'assistante de Man Ray, fut d'une importance décisive pour la postérité de l'œuvre d'Atget. A partir de 1925, elle se rendit à plusieurs reprises dans l'atelier du photographe, lui acheta quelques épreuves de ses maigres subsides et attira l'attention de ses amis artistes sur ce contemporain méconnu. A la mort d'Atget, Berenice Abbott et le cinéaste Julien Levy sauvèrent une part importante de sa succession. En 1930 parut, à l'initiative d'Abbott, un premier album réalisé à partir d'une sélection opérée dans ses archives. Enthousiasmé par cet ouvrage, Walter Benjamin fit peu après l'éloge d'Atget dans sa *Petite histoire de la photographie,* où il apparaissait comme un précurseur de la photographie surréaliste. La première pierre de sa gloire posthume se trouvait ainsi posée.

Depuis la fin des années soixante, l'œuvre d'Atget donne lieu à des études approfondies, mais les avis n'en continuent pas moins de diverger. Atget lui-même n'y est pas pour rien, car il semblerait qu'il ait brouillé les pistes à dessein. Aussi son œuvre, avec sa diversité, sa richesse et son ampleur, reste-t-elle un phénomène difficile à appréhender. Beaucoup d'arguments voudraient qu'on sorte enfin Atget du halo de mélancolie qui lui est attaché pour voir plutôt en lui le travailleur acharné qu'il était en réalité. L'entreprise d'Atget était en effet de constituer, à sa manière opiniâtre et volontaire, de gigantesques archives photographiques, virtuellement extensibles à l'infini. De par leur mouvance stylistique, ses clichés représentent une modernité liée à l'esthétique radicalement fonctionnelle, et définie par sa finalité, du médium technique qu'est la photographie.

ANDREAS KRASE

Archive of Visions
Inventory of Things
Eugène Atget's Paris

Eugène Atget is *the* photographer of Old Paris. Between 1897 and 1927 he recorded the imprint of history as no other photographer has done. Tracing the daily changes in the face of the city was not only his profession, but also his vocation. When he was laid to rest in August 1927, his funeral went virtually unnoticed, yet today Atget is regarded as one of the most important photographers in the history of the art. His work is regarded as the bridge between 19th century topographic photography and the so-called art documentary of the 20th century. Over and beyond their subject matter, his pictures can be seen as evidence of a passion, an uncompromising vision that took little account of technical perfection, but rather was entirely given over to creating a perception of pictorial space.

Atget's photographs show many different facets of Paris: not only the narrow streets that cut through the historic centre, whose buildings and magnificent palaces dated from before the French Revolution, but also stately Parisian squares, and the bridges and quays of the Seine. He photographed inn signs, shops and their displays, and aimed his camera into courtyards and stairwells, capturing the details of façades on some buildings and the interiors of others. But the street vendors, the small traders, refuse collectors and even the prostitutes in the poorer quarters featured equally in his photographs. Atget was particularly fascinated by seasonal bazaars and church festivals in the various corners of town, as well as by the parks of Versailles, Saint-Cloud and Sceaux, and the transitional areas between town and country.

Eugène Atget (1857–1927) was already in his mid-thirties when he became photographer. He had abandoned a career as an actor on the provincial stage, and subsequently tried in vain to earn his living as a painter. But around 1892 he put up a small plaque on his door with the words "Documents pour Artistes": he offered first and foremost photographs that could serve as studies for artists and craftsmen. In 1898 Atget began systematically photographing what was known as 'Old Paris', the part of the city dating from before 1789. That same year the Commission du Vieux Paris was convened by the Paris City Council to coordinate the existing efforts to research and document the historic parts of the city.

The sense of witnessing a historical watershed, with all the nostalgia that this implies, was probably stronger in Paris than in any other European city. Even the mastermind of the redevelopment programme in the capital, Baron Haussmann (1809–1891), had founded a commission devoted to the history of the city, the Service de travaux historiques, and was keen to record conditions before rebuilding began.

Atget was among the photographers who seized this situation as an opportunity. His main customers were institutions like the historical society, but museums, libraries, and collections maintained by schools of commercial art also bought his work. Unlike the majority of his professional colleagues, however, he maintained his independence. He himself decided which motifs were worth capturing and how they were to be shot. Glimpses inside and through buildings – the interpretation of spatial configurations – took increasing command of his interest. And with this he was quick to come up with new compositional formulae that flew in the face of convention. Strong contrasts, hard shadows that created an impression of depth, and intersecting forms became the hallmark of his photographic vision. Open gates and doorways reveal objects left by chance, which invite the viewer to imagine the hidden reality behind the pictures and to read the objects as clues to some story about ordinary life.

Precious little is known of Atget's background, his formal education, or his private life, although for many decades his fellow Paris-

ians could regularly watch the rather quirky figure of the photographer at work on the city streets. More than once the shadowy outline of the photographer was caught in his own images, particularly in reflections on the glass panes of doors and windows. The photograph *Boutique empire, rue de Faubourg-Saint-Honoré* from 1902 reveals Atget at work, respectably dressed and wearing a hat. Another well-known shot from this time also records a trace of his presence: in the reflective surface of a fire-screen we see a darkly shrouded being with a lens, like the symbol of a photographer. A shot of the restaurant *Au Tambour* from 1908 plays a more elaborate game with reflections: in the glass pane of the door Atget appears in profile, wearing a dark coat and standing next to the camera. Was it chance, or did Atget intend this enigmatic visual 'joke'? Whatever the case, his own head is replaced by that of a pale and disembodied figure standing in the hallway, probably the landlord. It was shots such as these that were later to captivate his contemporaries. His photographs demonstrate an ambiguous reality in which inside and outside seem to merge, and ghostly faces loom into sight and mingle with the reflections of the surrounding buildings.

Somewhat more is known of the way Atget lived and worked, because he photographed his rooms as part of a series of interiors. From 1899 he lived with his companion and assistant, Valentine Delafosse Compagnon (1847–1926), in a three-room flat on the fifth floor of 17 bis, rue Campagne-Première, Montparnasse. This quiet side street off the Boulevard Raspail was home to a number of renowned artists and models, and many more of lesser renown. Montparnasse had already become a gathering place for artists before the turn of the century, and its style and reputation drew ever greater numbers from abroad. Studios and workshops mushroomed in the area, and even buildings specially designed for artists were constructed. One of these, built in 1911 in the rue Campagne-Première, was eventually occupied during the twenties by Man Ray (1890–1976) – one of the 'discoverers' of Atget. The older photographer appears to have felt at home amidst these surroundings, and several of his neighbours numbered among his customers.

It was from here that Atget set out on his photographic expeditions. He used an old-fashioned wooden camera and the 18 x 24-cm glass negatives that were common at that time. The combined weight of his equipment was around 20 kilos, a burden that Atget had constantly to carry with him when he explored the streets of Old Paris by foot, descended the métro staircases, or travelled out to the suburbs by train. The photographer had a particular liking for close-range lenses, which heighten perspectival effects and achieve greater depth of focus than normal lenses. The way in which the eye is drawn into the depths of the picture, the at times crystalline appearance of the lines of perspective converging on the vanishing point, and the clear distinction of spatial levels were all consistent with the photographer's approach. Yet Atget was anything but a perfectionist in technical matters. Nor did his motives demand this, for his photographs were taken to serve as documents or source material. Similarly, long exposure times led to blurred images from moving objects, or even traces of mysterious, phantom-like entities that appear on the plate – but none of this was detrimental to the purpose of the photographs.

During the mid-1920's Atget was discovered by the young Avantgarde. Man Ray made a modest collection of Atget photographs, and was especially taken by those images that he found "somewhat reminiscent of Dada or Surrealism". In 1927 he even convinced Atget to allow some of his photographs to be printed in the journal *La Révolution surréaliste*. Clearly the old photographer was set on avoiding any misunderstandings, for he insisted that his name was omitted from the journal's pages. He justified his demur with the famous statement that his pictures were "documents, nothing but documents" ("c'est du document et rien d'autre").

The survival of Atget's work owes much to the commitment of Man Ray's assistant, Berenice Abbott (1898–1991). From 1925 onwards, she made a number of visits to the photographer in his studio, bought prints with her modest financial resources, and directed other artists of her acquaintance to their unrecognized contemporary. Berenice Abbott and the American film-maker Julien Levy later secured a large portion of the artist's estate. In 1930, on Berenice Abbott's initiative,

came the first publication of Atget's work in book form, containing a selection of works from Abbott's archive. Soon after, one of the book's enthusiasts, Walter Benjamin, wrote a historical overview of photography in which he hailed Atget as a forerunner of Surrealist photography. With this, the foundations of Atget's fame were laid once and for all.

Atget's work has been the subject of several in-depth studies since the late Sixties. Yet there continue to be great divergences of opinion. Atget shares no small blame in this, for he appears intentionally to have covered his tracks. Simultaneously the sheer diversity, range and wealth of his images continue to make it difficult to come to terms with his oeuvre. There are strong arguments for absolving Atget from any charge of hankering after nostalgia, and instead regarding him as the diligent worker he was. In his own idiosyncratic way, Atget set about creating a gigantic, potentially infinite, pictorial archive that was always tight on the heels of change. The stylistic disjointedness of his photographs constitutes a form of Modernism that is consciously bound to a radically functional photographic aesthetic – a photography defined by purpose.

ANDREAS KRASE

Archiv der Blicke
Inventar der Dinge
Eugène Atgets Paris

Eugène Atget war *der* Photograph des Alten Paris. Wie kein anderer hielt er zwischen 1897 und 1927 die Zeugnisse der Geschichte in seinen Bildern fest. Es war sein Alltagswerk, seine Profession, aber auch seine Berufung, der Veränderung der Stadt mit der Kamera zu folgen. Als er im August 1927 zu Grabe getragen wurde, nahm kaum jemand davon Notiz. Heute hingegen zählt man Atget zu den bedeutendsten Persönlichkeiten der Photographiegeschichte. Sein Werk gilt als Bindeglied zwischen der topographischen Photographie des 19. Jahrhunderts und dem künstlerischen Dokumentarismus des 20. Jahrhunderts. Jenseits ihrer Thematik können die Bilder als Zeugnisse einer Passion, einer visuellen Unbedingtheit gesehen werden, der die technische Perfektion wenig, die Übermittlung einer räumlichen Wahrnehmung aber alles galt.

Atgets Aufnahmen zeigen Paris in unterschiedlichen Facetten: die engen Straßenschluchten des historischen Zentrums mit den alten Gebäuden und den prächtigen Palästen aus der Zeit vor der Französischen Revolution, die Plätze, Brücken und die Kais am Ufer der Seine. Er lichtete Geschäfte mit ihren Auslagen und Wirtshausschilder ab, blickte mit der Kamera in Höfe und Treppenhäuser, nahm Details der Fassaden auf und photographierte die Innenausstattung mancher Gebäude. Aber auch die Straßenhändler, die kleinen Gewerbetreibenden, die Müllsammler und schließlich die Prostituierten der ärmlichen Vororte wurden seine Modelle. Mit besonderem Interesse wandte er sich dem Jahrmarkt, den Kirchweihfesten in den verschiedenen

Stadtteilen zu und hielt ihr fantastisches Dekor fest. Das Paris des Eugène Atget umfasst aber auch die Umgebung, die Parks von Versailles, Saint-Cloud und Sceaux, die Übergangszonen zum dörflichen Umland.

Eugène Atget (1857–1927) war schon Mitte dreißig, als er Photograph wurde. Seine Laufbahn als Schauspieler an verschiedenen Provinztheatern hatte er abgebrochen und sich anschließend eine Zeit lang vergeblich als Maler versucht. „Documents pour Artistes" lautete die Inschrift auf einer kleinen Tafel, die er etwa 1892 an seiner Wohnungstür anbrachte. Er bot vor allem Aufnahmen an, die als Vorlagen für Künstler und Kunsthandwerker dienen konnten.

Ab 1898 ging Atget dazu über, systematisch die baulichen Zeugnisse aus der Zeit vor 1789, das so genannte Alte Paris abzulichten. In diesem Jahr war auf Beschluss des Pariser Stadtrats die Commission du Vieux Paris zusammengetreten, die sich die Aufgabe stellte, die bisherigen Bemühungen bei der Erforschung und der Dokumentation des historischen Paris zusammenzufassen. Wie wohl in keiner anderen europäischen Stadt verband sich in Paris die Empfindung, an einer Zeitenwende zu stehen, mit dem nostalgischen Interesse an der Vergangenheit. Selbst der Urheber des gründerzeitlichen Stadtumbaus, Baron Haussmann (1809–1891), hatte sich als Gründer einer stadtgeschichtlichen Kommission, des Service de travaux historiques, darum bemüht, den Zustand vor den baulichen Veränderungen festhalten zu lassen.

Atget gehörte zu jenen Photographen, die in dieser Situation ihre Chance sahen. Seine Abnehmer waren nun zumeist Institutionen wie die historische Gesellschaft, aber auch Museen und Bibliotheken sowie die Mustersammlungen kunstgewerblicher Lehranstalten. Im Unterschied zu den meisten seiner Berufskollegen bewahrte er jedoch seine Unabhängigkeit. Er selbst entschied in der Regel, welche Motive er für abbildenswert hielt und in welcher Weise er sie abgebildet sehen wollte. Sein Interesse richtete sich auf Durchblicke und Einblicke, auf die Interpretation räumlicher Konstellationen. Dabei entwickelte er gestalterische Lösungen, die den Bruch mit der Konvention nicht scheuten. Starke Lichtgegensätze und harte, Plastizität vermittelnde Schatten sowie Formüberschneidungen wurden zu Markenzeichen

seiner Bildauffassung. Offene Tore und Türen erlauben den Blick auf zufällig liegen gelassene Gegenstände, die den Betrachter dazu auffordern, sich den in den Bildern verborgenen Realitätsgehalt zu vergegenwärtigen und das photographisch Erfasste als Andeutung einer Alltagsgeschichte zu verstehen.

Über Atgets Herkunft, seine Ausbildung und sein Privatleben ist nur sehr wenig bekannt, obwohl die Pariser den Photographen als etwas schrullige Gestalt über Jahrzehnte hinweg in den Straßen ihrer Stadt bei der Arbeit beobachten konnten. In manchen Aufnahmen hat sich sein schemenhaftes Porträt erhalten, vor allem als Reflexion in den spiegelnden Glasflächen von Türen und Fenstern. Die Photographie *Boutique empire, rue du Faubourg-Saint-Honoré* von 1902 zeigt ihn in bürgerlicher Kleidung mit Hut bei der Arbeit. Auch eine andere bekannte Aufnahme jener Zeit bewahrt die Spur seiner Anwesenheit: In einer spiegelnden Kaminabdeckung zeichnet sich ein dunkel verhülltes Wesen mit einem Objektivauge ab, wie ein Sinnbild des Photographen. Eine Aufnahme des Gasthauses *Au Tambour* aus dem Jahre 1908 führt das Spiel der Reflexionen noch weiter. Atget wird in der Scheibe der Tür sichtbar, seitlings im dunklen Mantel neben der Kamera stehend. Ob nun der Zufall mitspielte oder der Photograph bei dem hintergründigen Bildwitz Regie führte – an Stelle seines Kopfes schwebt, fahl und körperlos, das Gesicht eines Innenstehenden, vermutlich des Wirtes. Es sind Aufnahmen wie diese, die die späteren Betrachter seiner Photographien begeistern sollten. Die Photographien bezeugen eine doppelbödige Realität – in der Durchdringung von Innen und Außen, in der Kombination von geisterhaft aufscheinenden Gesichtern und Reflexionen des städtischen Umfelds.

Über die Umstände seines Wohnens und Arbeitens sind wir etwas besser unterrichtet, da Atget seine Räume für eine Serie mit Interieurs photographiert hat. Seit 1899 lebte er zusammen mit seiner Lebensgefährtin und Assistentin Valentine Delafosse Compagnon (1847–1926) in einer Dreizimmerwohnung in der fünften Etage des Hauses Nummer 17 bis in der Rue Campagne-Première am Montparnasse. In dieser stillen Seitenstraße des Boulevard Raspail lebten neben bekannten Künstlern und Modellen auch viele noch unbekannte. Die Gegend am

Montparnasse war schon vor der Jahrhundertwende zum Künstler-treff geworden, dessen Flair immer mehr Menschen aus dem Ausland anzog. Die Zahl der Ateliers und Werkstätten nahm ständig zu und es wurden sogar besondere Gebäude für Künstler errichtet. In einem von ihnen, das 1911 in der Rue Campagne-Première erbaut wurde, bezog in den zwanziger Jahren einer der Entdecker Atgets, Man Ray (1890–1976), sein Quartier. Atget scheint sich in dieser Umgebung wohl gefühlt zu haben und einige seiner Nachbarn waren auch seine Kunden. Von hier aus brach er zu seinen Exkursionen auf. Für die Auf-nahmen verwandte er eine altertümliche Holzkamera und die damals üblichen Glasnegative im Format 18 x 24 cm. Seine Ausrüstung wog ins-gesamt etwa 20 Kilogramm. Diese Last führte Atget ständig mit sich, wenn er die Straßen des Alten Paris zu Fuß erkundete, wenn er zu den Metro-Stationen hinabstieg oder mit den Vorortzügen hinausfuhr. Er hegte eine Vorliebe für Objektive mit einer kurzen Brennweite, die das Fluchten des Raumes verstärken und im Vergleich zum Normalobjek-tiv eine größere Tiefenschärfe erreichen. Der starke Tiefensog, die gele-gentlich kristallisch anmutende Zuspitzung der bildeinwärts führen-den Linien, schließlich die klare Trennung räumlicher Ebenen entsprachen seinem Bildverständnis. In technischen Belangen war er allerdings kein Perfektionist. Die Funktion seiner Photographien als Vorlagen und Dokumente erforderte dies auch nicht. Und die durch lange Belichtungszeiten entstandenen Bewegungsunschärfen in den Bildern bis hin zu mysteriös schwebenden Schemen von Menschen und Dingen waren dem Einsatz der Photographien nicht abträglich.

Um die Mitte der zwanziger Jahre wurde Atget von jungen Avant-gardekünstlern entdeckt. Man Ray legte eine kleine Sammlung mit Atget-Photographien an. Ihm gefielen vor allem jene Bilder, die ihn „ein bisschen an Dada oder den Surrealismus" erinnerten. Und er rang Atget 1927 die Erlaubnis ab, einige Aufnahmen in der Zeitschrift *La Révolution surréaliste* abdrucken zu dürfen. Der Photograph wollte sich sichtlich vor Missdeutungen schützen und bestand darauf, dass sein Name in der Zeitschrift nicht genannt wurde. Er begründete dies mit den berühmten Worten, dass seine Bilder Dokumente seien und nichts anderes [„c'est du document et rien d'autre"].

Für die Überlieferung des Werkes war das Engagement der Assistentin Man Rays, Berenice Abbott (1898–1991), von entscheidender Bedeutung. Ab 1925 besuchte sie den Photographen mehrfach in seinem Atelier, kaufte von ihrem knappen Geld Abzüge und wies auch ihre Künstlerfreunde auf den verkannten Zeitgenossen hin. Berenice Abbott und der amerikanische Filmemacher Julien Levy sicherten schließlich einen bedeutenden Teil des Nachlasses. Auf Betreiben von Abbott erschien 1930 die erste Monographie mit einem Querschnitt der Bilder aus ihrem Archiv. Walter Benjamin, von diesem Buch begeistert, rühmte Atget kurz darauf in seiner Photographiegeschichte als Vorläufer der surrealistischen Photographie. Damit schuf er den Grundstock für dessen Nachruhm.

Seit Ende der sechziger Jahre ist Atgets Werk gründlich untersucht worden, doch nach wie vor gehen die Meinungen weit auseinander. Daran ist Atget selbst nicht unbeteiligt gewesen, denn er scheint die Spuren seines Lebens mit Absicht verwischt zu haben. Und so ist sein Werk in seiner Vielfalt, seiner Bildfülle und in seinem Umfang immer noch ein schwer fassliches Phänomen. Vieles spricht dafür, ihn aus einer eher nostalgischen Sicht zu entlassen und als den beharrlichen Arbeiter zu verstehen, der er tatsächlich war. Atget unternahm in seiner eigenwilligen Art die Erschaffung eines riesigen, potenziell unbegrenzten Bildarchivs, das der Veränderung immer auf dem Fuße folgte. Seine Aufnahmen repräsentieren in ihrer stilistischen Sprunghaftigkeit eine Moderne, die sich der radikal funktionalen, über ihre Zwecke definierten Ästhetik des technischen Bildmediums Photographie verpflichtet weiß.

Cour de Rouen ou de Rohan (6e arr.), 1915

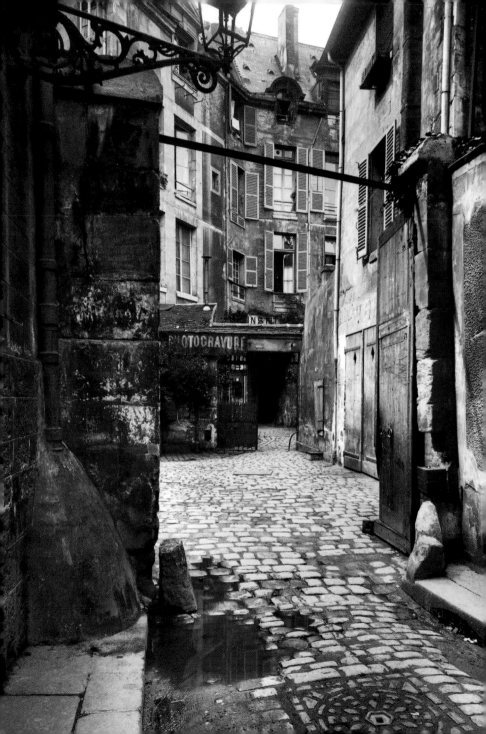

Tradesmen and
Traders on the
Streets of Paris

Les Petits Métiers
de Paris

Gewerbetreibende
und Händler auf den
Straßen von Paris

EUGÈNE ATGET

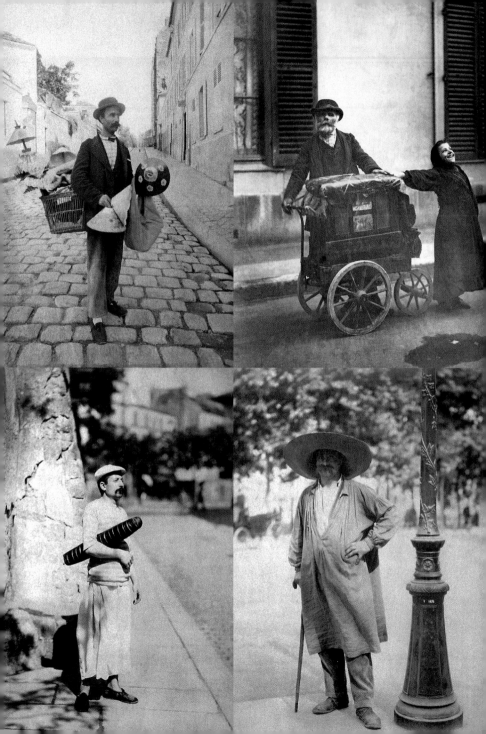

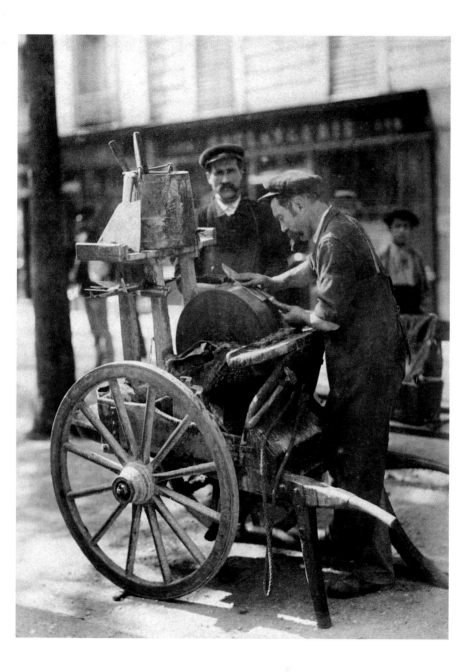

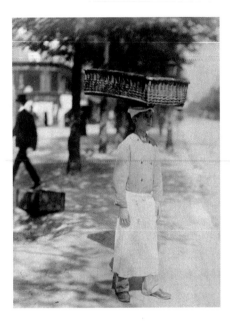 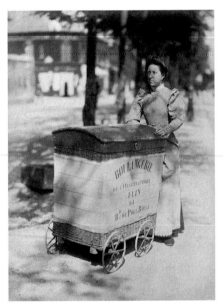

Apprenti pâtissier | Apprentice pastry-cook
Konditorlehrling
c. 1898–1899

Porteuse de pains | Bread delivery-woman
Frau, die Brot ausliefert
1899

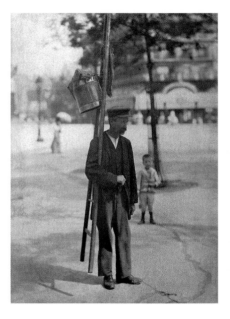

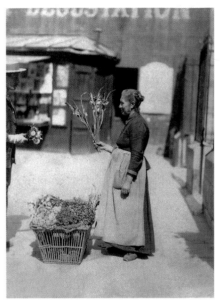

Nettoyeur de devantures | Window-cleaner
Fensterputzer
Avenue des Gobelins (13ᵉ arr.), juin 1901

Marchande de fleurs | Flower lady
Blumenverkäuferin
Rue Mouffetard (5ᵉ arr.), 1899

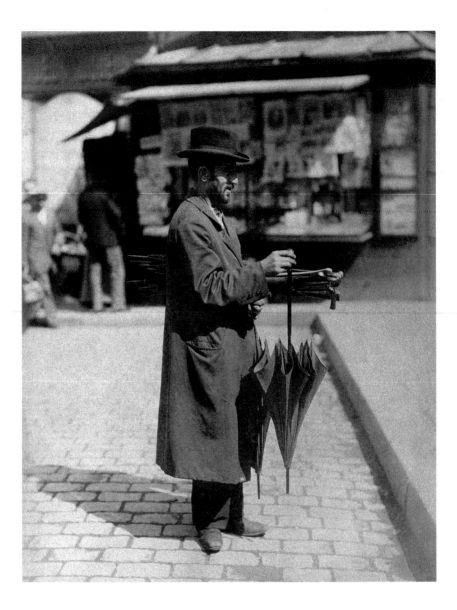

Marchand de parapluies | Umbrella man | Regenschirmverkäufer
Rue Mouffetard devant l'église Saint-Médard (5ᵉ arr.), c. 1899–1900

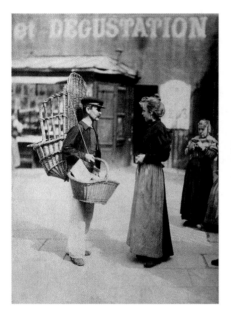 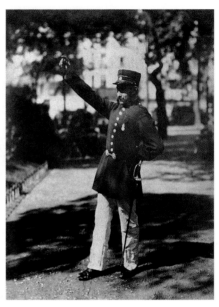

Marchand ambulant | Peddler
Straßenhändler
Rue Saint-Médard (5ᵉ arr.), 1899

Gardien de square | Park attendant
Platzaufseher
août 1900

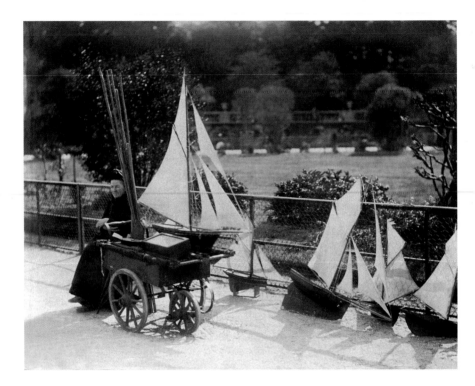

Loueuse de bateaux modèles réduits | Model-boat hirer | Modellboot-Verleiherin
Jardin du Luxembourg (6^e arr.), 1898

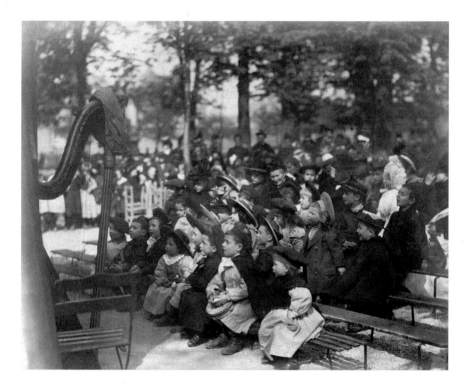

Guignol | Punch and judy show | Kasperletheater
Jardin du Luxembourg (6e arr.), 1898

EUGÈNE ATGET

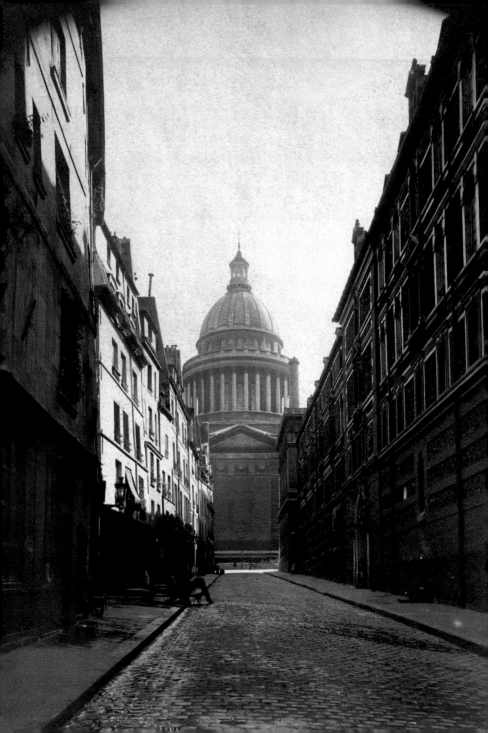

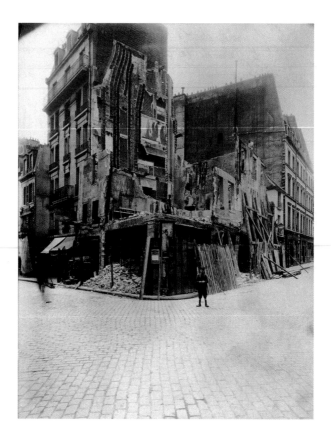

La maison n° 5 de la rue Thouin (5e arr.), 10 août 1910
Le jour de sa démolition | The day of its demolition | Am Tag der Zerstörung

Page | Page | Seite: 47
Le Panthéon, vu de la rue Valette (5e arr.), 1898

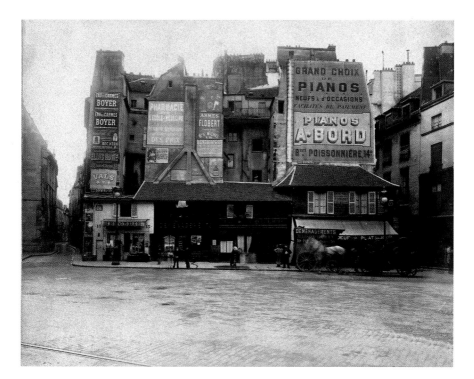

Place Saint-André-des-Arts (6ᵉ arr.)
Avant la démolition du 10 juillet 1898 | Before its demolition on 10th July 1898 | Vor dem Abriss
am 10. Juli 1898

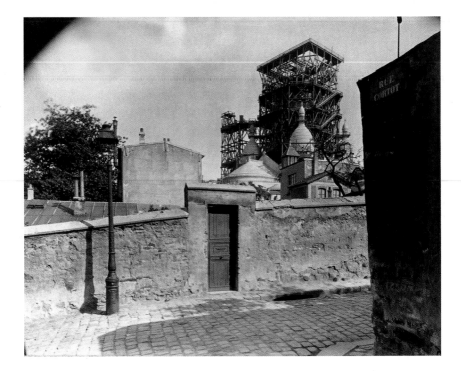

Montmartre, vu de la rue Cortot (18e arr.), 1899
Basilique du Sacré-Cœur en construction

Montmartre, basilique du Sacré-Cœur, rue de la Barre (18e arr.), août 1900

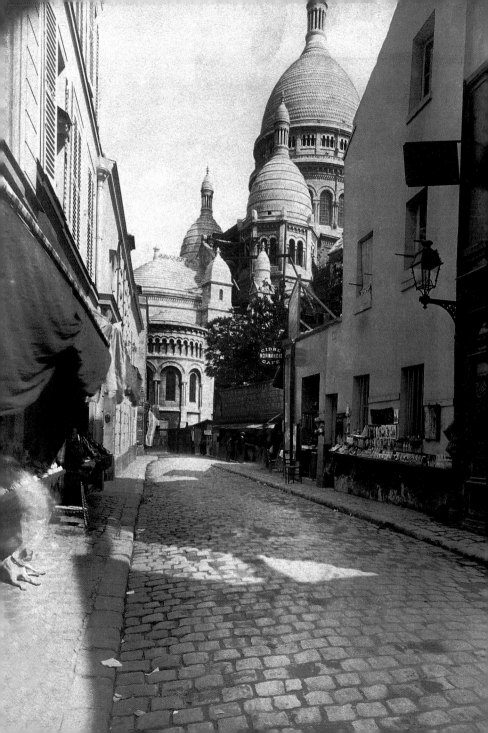

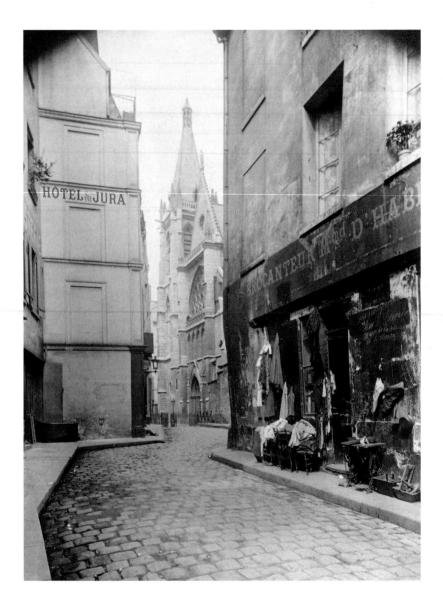

Hôtel du Jura, église Saint-Séverin, rue des Prêtres-Saint-Séverin (5ᵉ arr.), 1899

Le Moulin-Rouge, 86 boulevard de Clichy (18ᵉ arr.), 1911

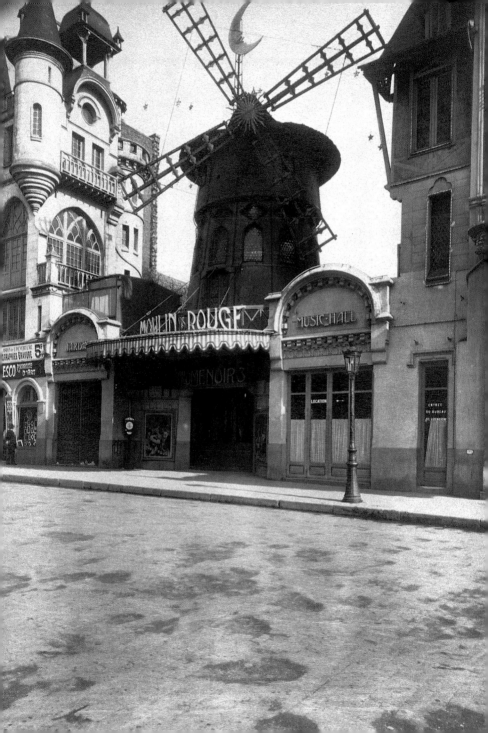

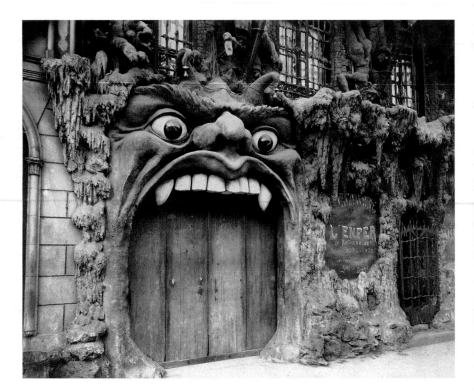

Cabaret artistique « L'Enfer », 53 boulevard de Clichy (9e arr.), 1911

Cabarets artistiques « Le Ciel » et « L'Enfer », boulevard de Clichy (9e arr.), 1911

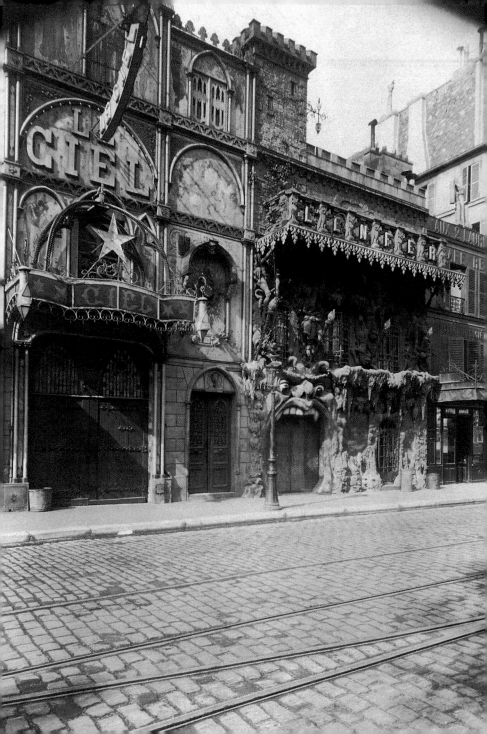

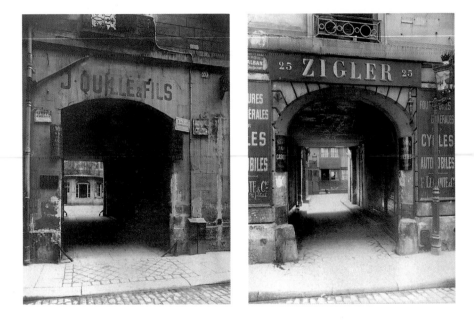

« J. Quille & Fils », ancien Hôtel
20 rue Ferdinand Duval (4ᵉ arr.), 1910

« Zigler », entrée de l'ancien Hôtel
25 rue des Blancs-Manteaux (4ᵉ arr.), 1910

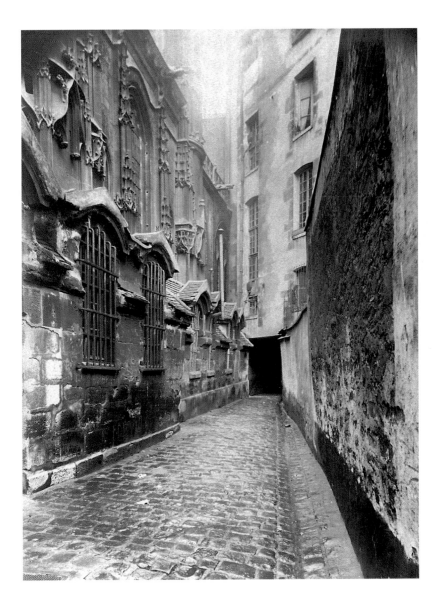

Ancien charnier | Former charnel-house | Ehemaliges Beinhaus
Eglise Saint-Gervais (4ᵉ arr.), 1899

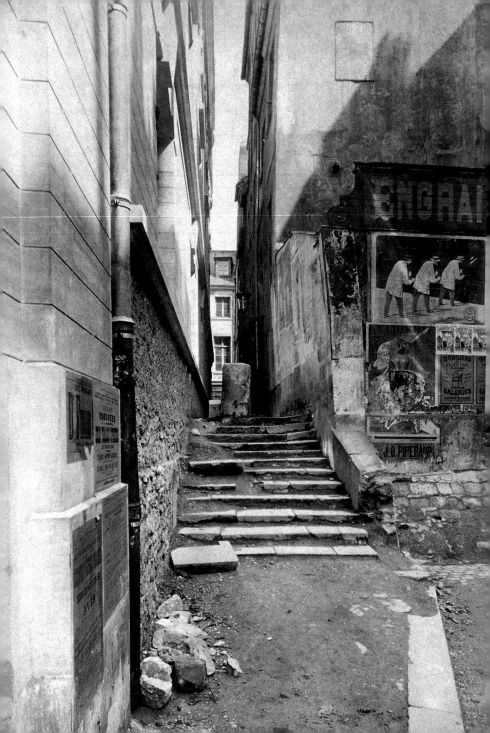

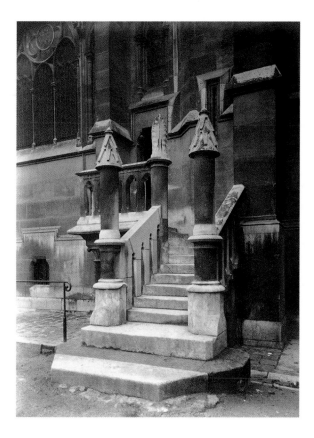

Porche méridional | South porch | Südportal
Notre-Dame, 1905

Rue Grenier-sur-l'Eau (4e arr.), juin 1900

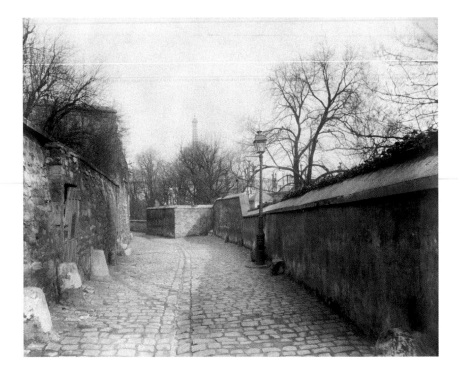

Passy, rue Berton (16e arr.), mars 1901

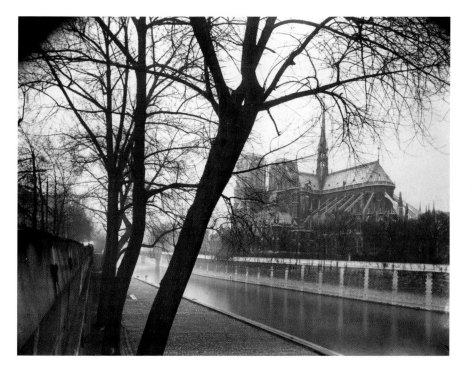

Notre-Dame, quai de Montebello (5ᵉ arr.), 1922

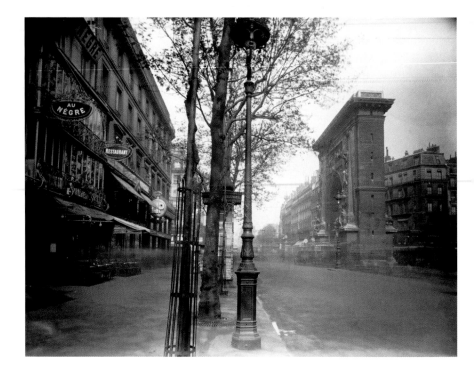

Boulevard Saint-Denis (16e arr.), 1926

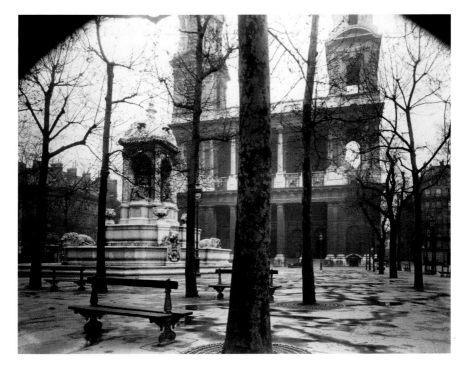

Eglise Saint-Sulpice (6ᵉ arr.), avril 1926

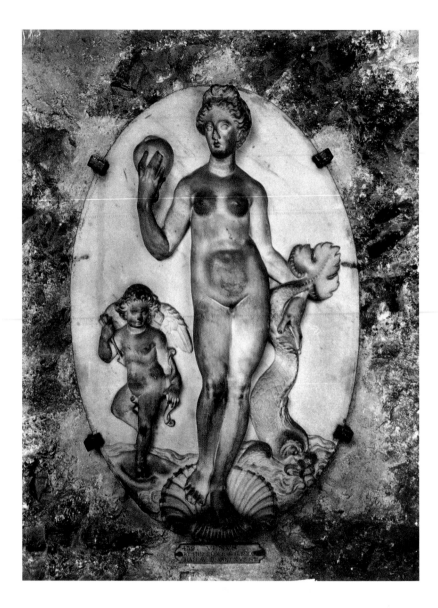

Vénus, XVIᵉ siècle, musée de Cluny (5ᵉ arr.), 1911
Haut-relief provenant du château d'Anet | High-relief from the château d'Anet
Hochrelief aus dem Schloß Anet

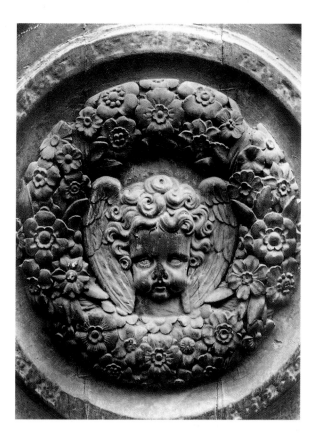

Porte de l'église Saint-Nicolas-des-Champs, détail (3e arr.), 1911

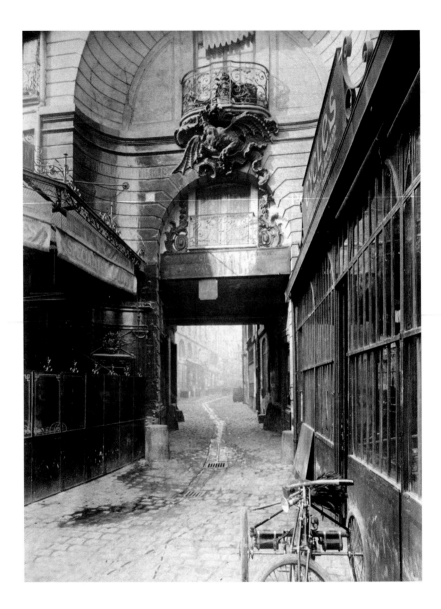

Cour du Dragon, 50 rue de Rennes (6ᵉ arr.), 1900

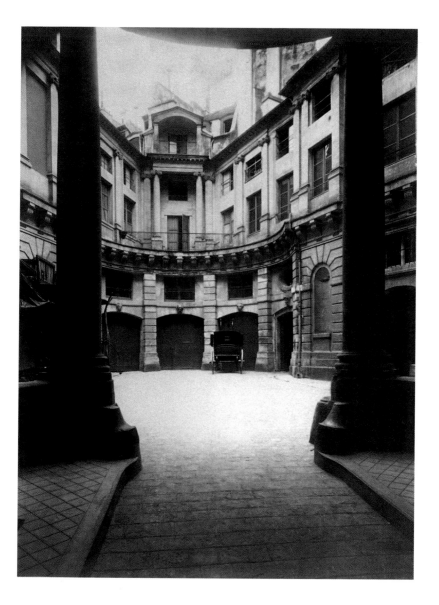

Hôtel de Beauvais, 68 rue François Miron (4e arr.), avril 1902

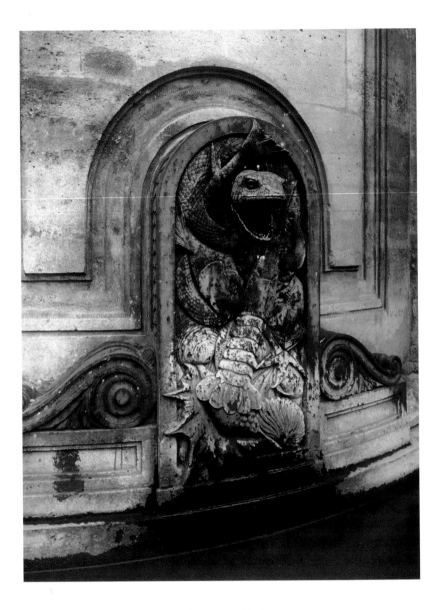

Fontaine Cuvier, devant le jardin des Plantes, 1905
Pomateau: Sculpture | Sculpture | Skulptur

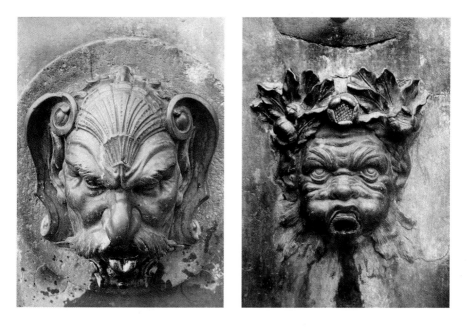

Ancienne fontaine Saint-Benoît, rue des Ecoles
(5ᵉ arr.), 1901

Fontaine Garancière
12 rue Garancière (6ᵉ arr.), 1900

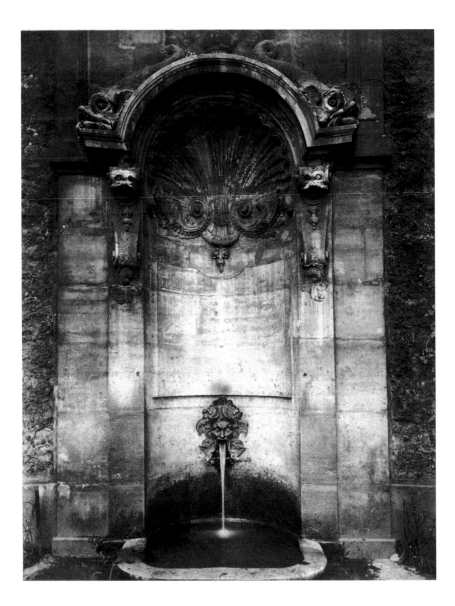

Ancienne fontaine Childebert, place Monge (5e arr.), octobre 1900

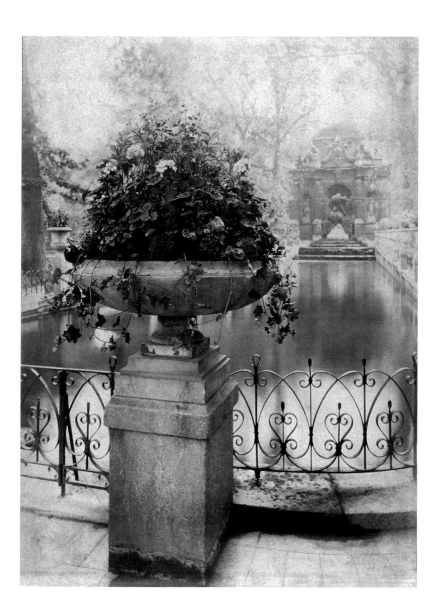

Jardin du Luxembourg, fontaine de Médicis (6e arr.), 1898

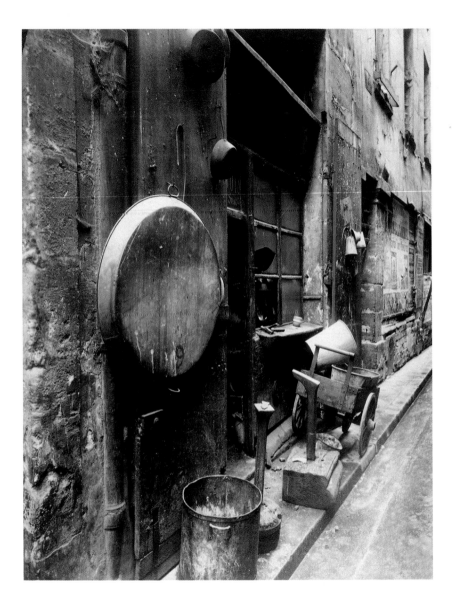

Boutique d'étamage | Tinning shop | Zinn- und Metallwarengeschäft
3 rue de La Reynie (4e arr.), 1912

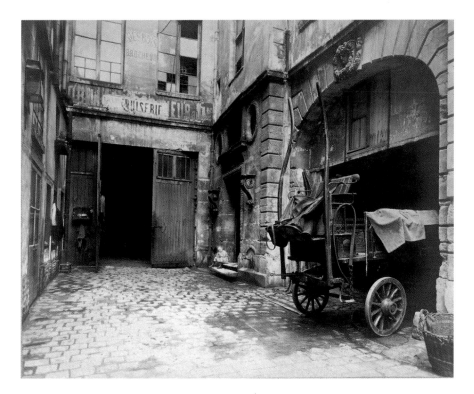

Ancienne maîtrise | Former choir school | Ehemalige Kantorei
Saint-Eustache, 25 rue du Jour (1^{er} arr.), 1902

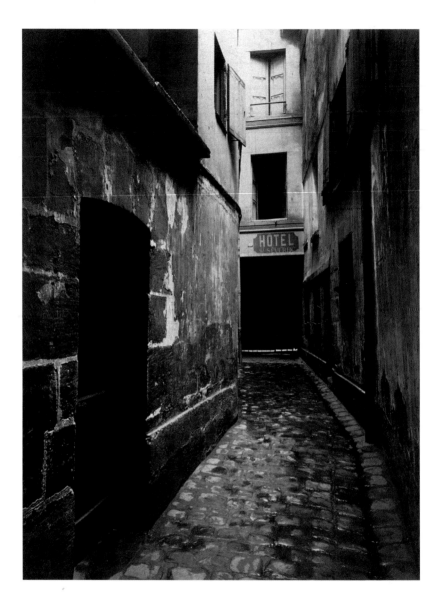

Entrée du presbytère | Entrance to the presbytery | Eingang zum Presbyterium
Saint-Séverin, 12 rue de la Parcheminerie (5ᵉ arr.), 1912

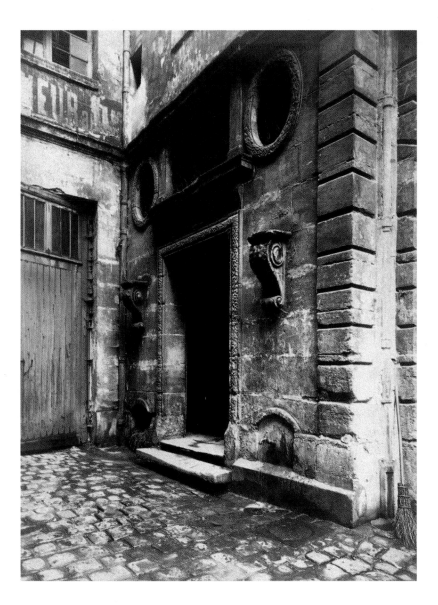

Ancienne maison de la maîtrise | Former choir school | Ehemalige Kantorei
Saint-Eustache, 25 rue du Jour (1er arr.), 1902

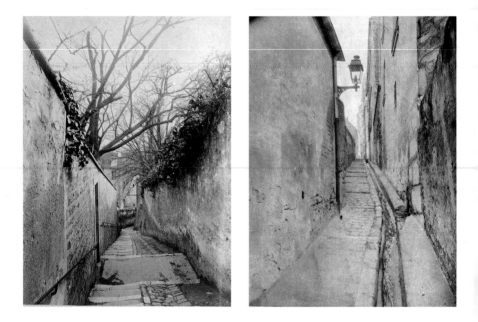

Passy, passage des Eaux (16e arr.), mars 1901 Butte-aux-Cailles, passage Vandrezanne
 (13e arr.), 1900

Passy, passage des Eaux (16e arr.), mars 1901

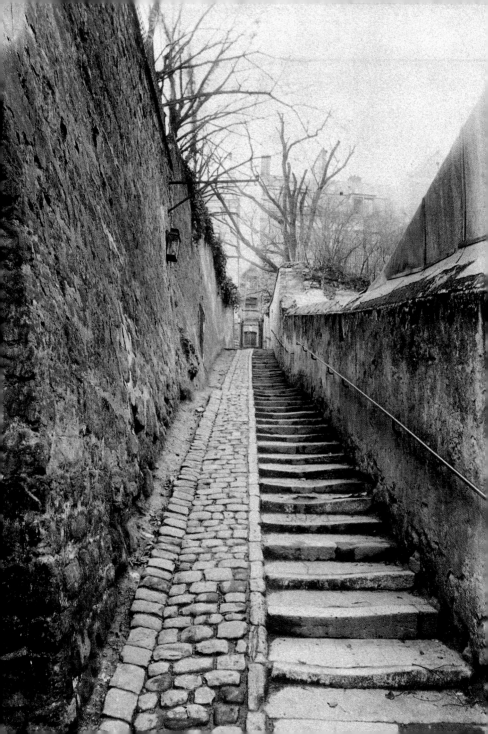

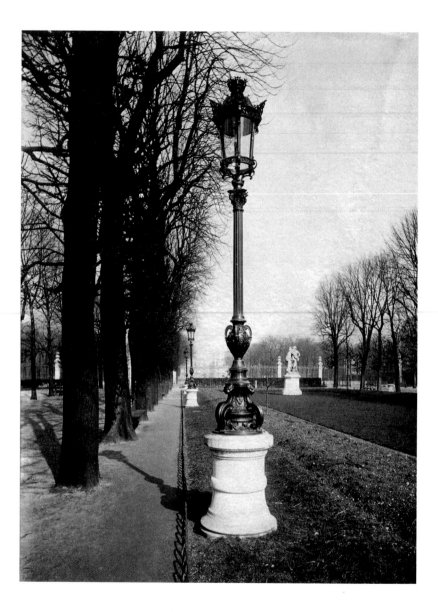

Jardin du Luxembourg (6e arr.), 1903

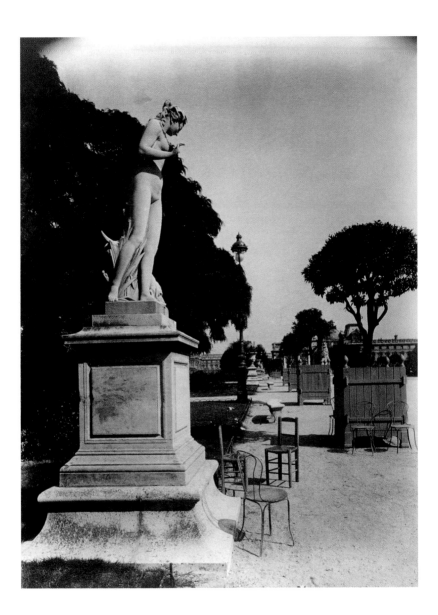

Jardin des Tuileries (1^{er} arr.), avril 1907
L'Evêque: *Diane chasseresse* | *Diana the Huntress* | *Diana jagend*

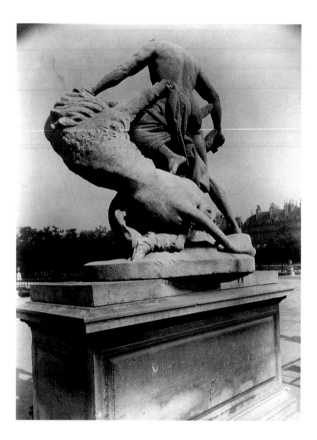

Jardin des Tuileries (1er arr.), 1911
Dieudonné: Alexandre vainqueur du lion | Alexander Overcoming the Lion
Alexander den Löwen bezwingend

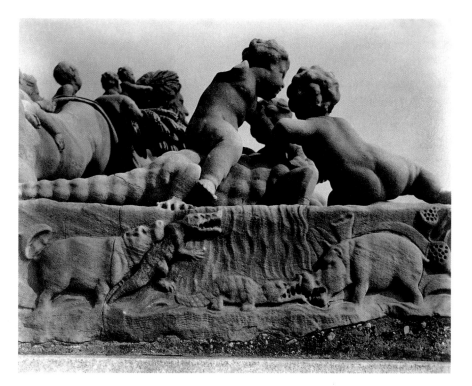

Jardin des Tuileries (1er arr.), 1911
Bourdic: Le Nil (détail) | The Nile (detail) | Der Nil (Detail)

Eglise Saint-Julien-le-Pauvre (5ᵉ arr.), 1904

Saint-Sulpice (6ᵉ arr.), 1903
Chalgrin: Orgue | Organ | Orgel; Cladion: Statues | Statues | Statuen

Stalle | Misericord | Chorgestühl
Saint-Gervais-Saint-Protais (4e arr.), 1904

Vue prise sur les toits | Flying buttresses | Strebepfeiler
Eglise Saint-Séverin (5e arr.), 1903

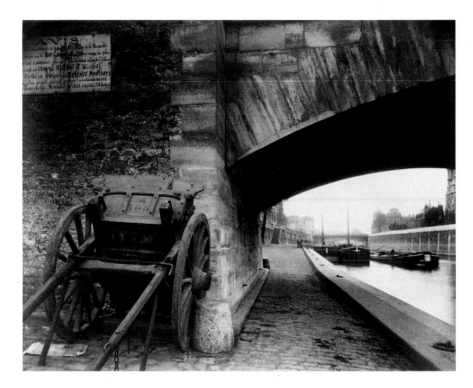

Quai de la Tournelle (5e arr.), 1911

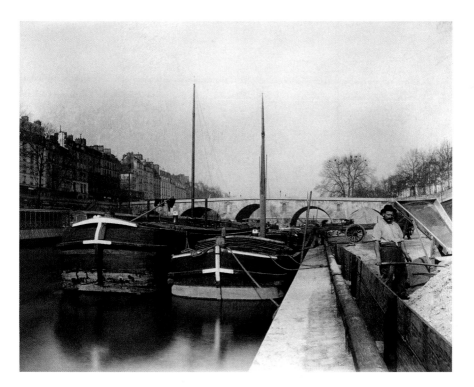

Quai des Célestins et île Saint-Louis (4ᵉ arr.), 1903

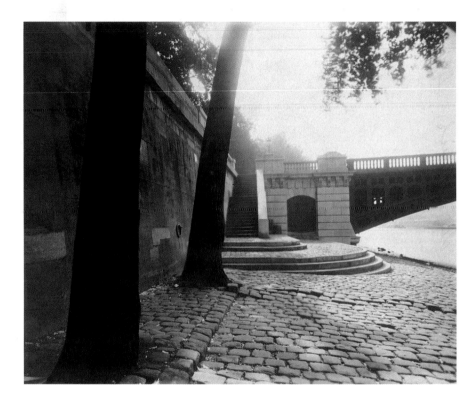

Port des Tuileries (1er arr.), 1913

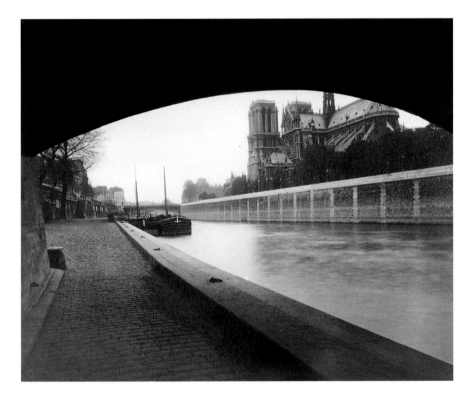

Un coin du quai de la Tournelle (5e arr.), 1911

Stairs

Escaliers

Treppen

EUGÈNE ATGET

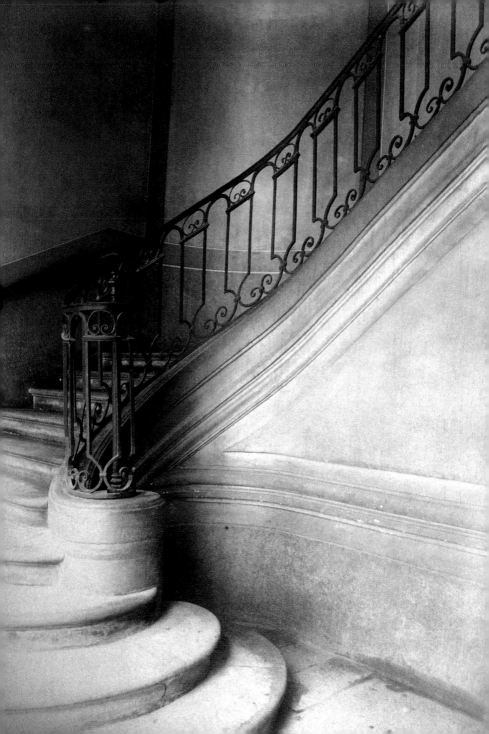

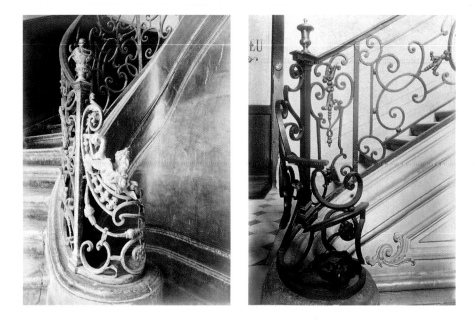

Hôtel d'Epernon, 110 rue Vieille-du-Temple (4ᵉ arr.), mai 1901

Hôtel Dodun, 21 rue de Richelieu (1ᵉʳ arr.), 1904

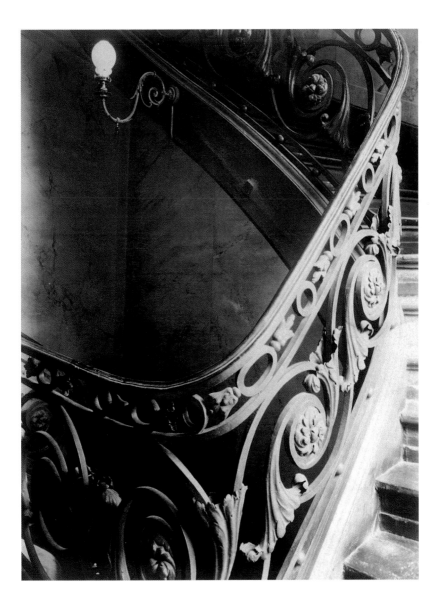

Escalier | Staircase | Treppe
Hôtel de Sully-Charost, 11 rue du Cherche-Midi (6e arr.), c. 1904–1905

Page | Page | Seite: 91
Hôtel Le Charron, 15 quai de Bourbon (4e arr.), 1900

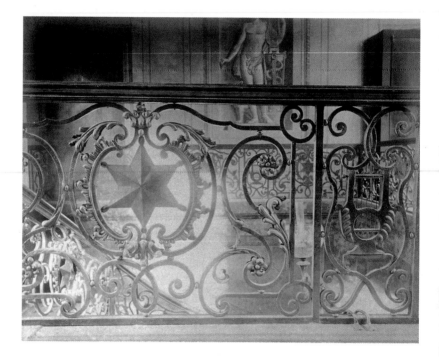

Hôtel du marquis de Chantosme, 6 rue de Tournon (6ᵉ arr.), septembre 1900

Hôtel du marquis de Lagrange, 4 et 6 rue de Braque (3ᵉ arr.), 1901

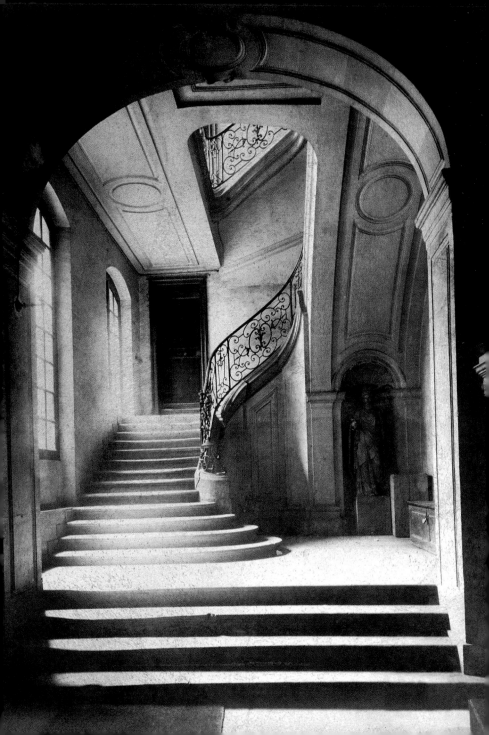

Intérieurs
parisiens

EUGÈNE ATGET

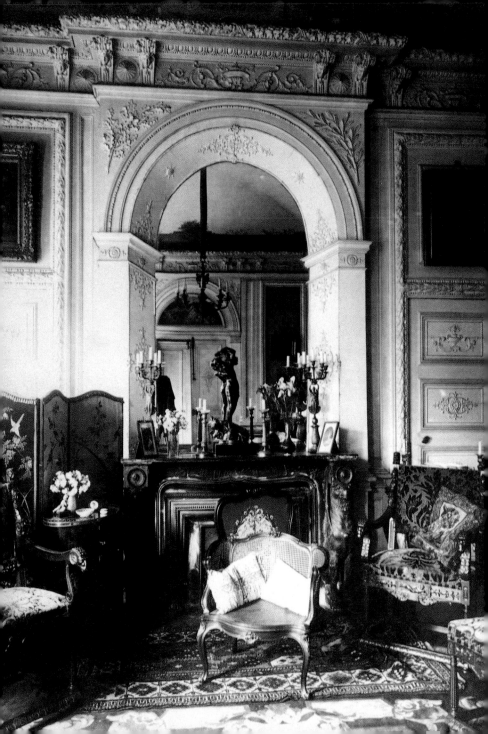

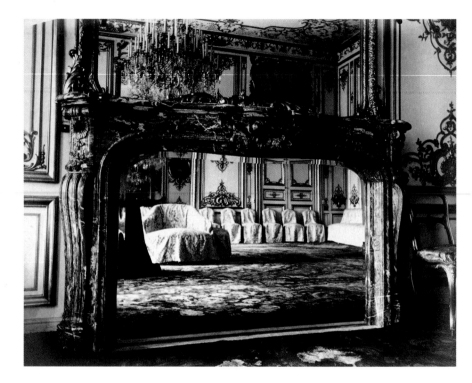

Ambassade d'Autriche | Austrian Embassy | Österreichische Botschaft
Hôtel de Matignon, 57 rue de Varenne (6e arr.), 1905

Page | Page | Seite: 97
Ancien château de Villiers, pavillon de musique du duc de Aumale
61 bis rue de Villiers, Neuilly-sur-Seine, 1914

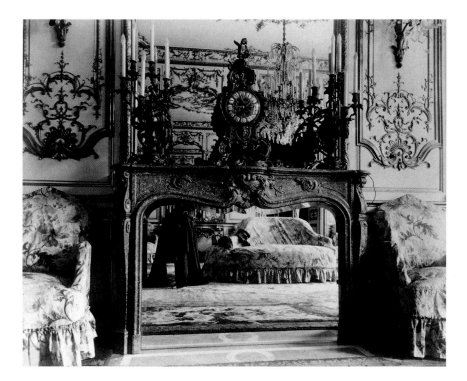

Ambassade d'Autriche | Austrian Embassy | Österreichische Botschaft
Hôtel de Matignon, 57 rue de Varenne (6ᵉ arr.), 1905

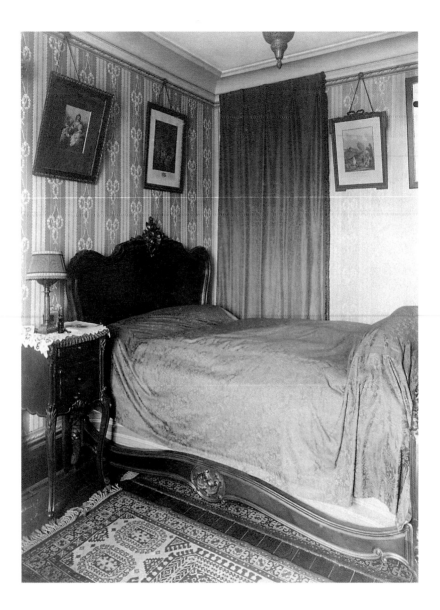

Intérieur de Mme D., petite rentière | Room of a small investor
Interieur der Kleinanlegerin
Boulevard de Port-Royal (5ᵉ arr.), 1910

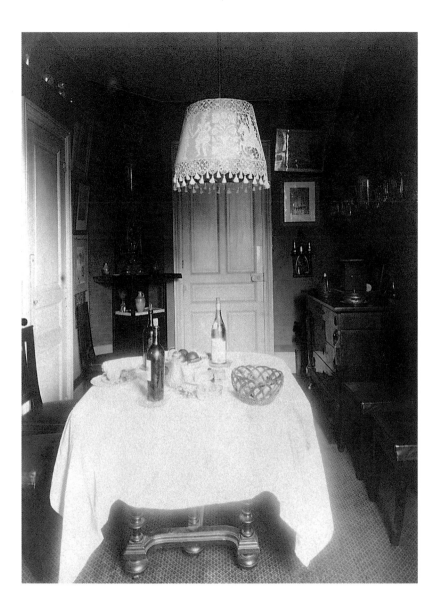

Intérieur de M. C., décorateur | Decorator's room
Interieur des Dekorateurs
Rue du Montparnasse (6ᵉ arr.), 1910

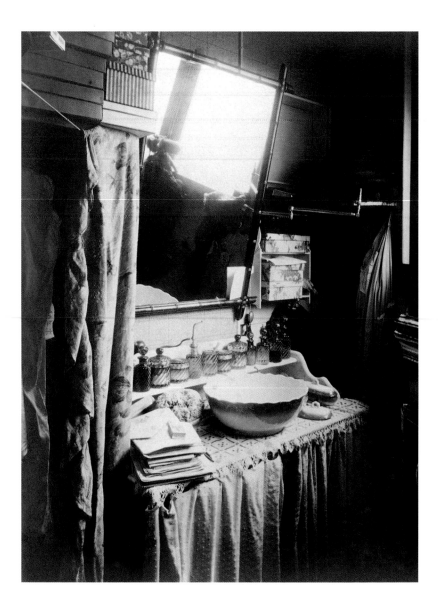

Intérieur de Mme C., modiste | Milliner's room | Interieur der Hutmacherin
Place Saint-André-des-Arts (6e arr.), 1910

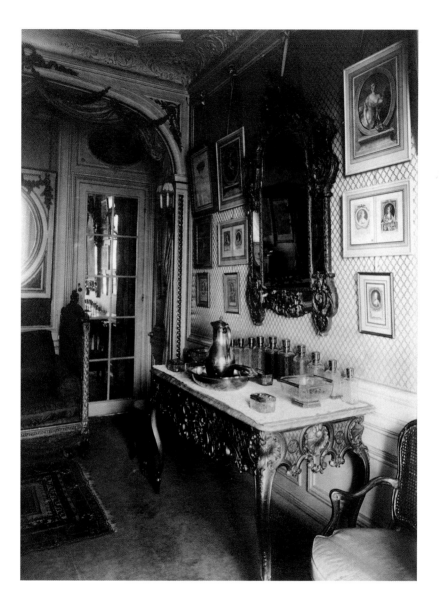

Intérieur de Mlle Sorel de la Comédie-Française
Avenue des Champs-Elysées (8e arr.), 1910

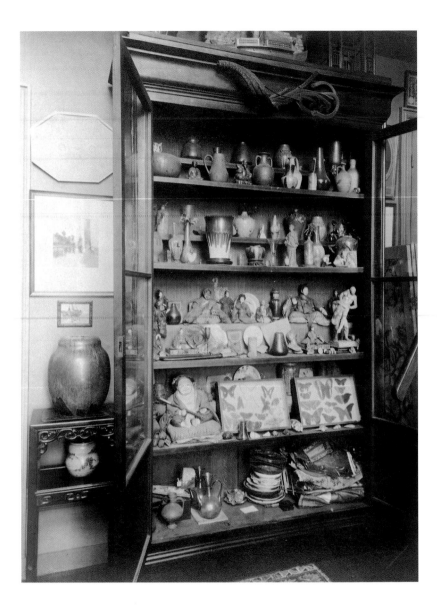

Intérieur de M. B., collectionneur | Collector's room | Interieur des Sammlers
Rue de Vaugirard (15e arr.), 1910

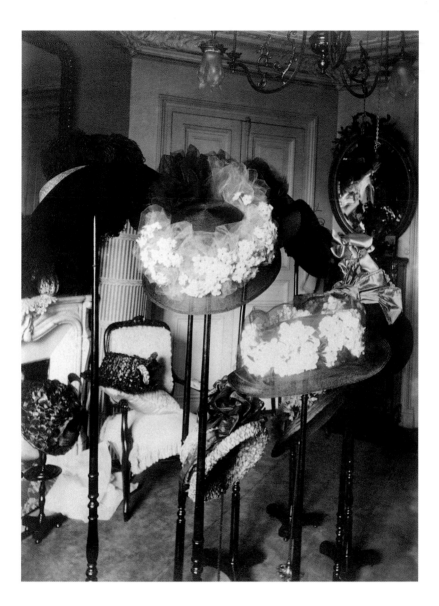

Le salon de Mme C., modiste | Showroom of the milliner Mme C. | Ausstellungsraum der
Hutmacherin Mme C.
Place Saint-André-des-Arts (6e arr.), 1910

Trades, Shops,
Window Display

Métiers,
boutiques et
étalages

Gewerbeläden,
Schaufensteranlagen

EUGÈNE ATGET

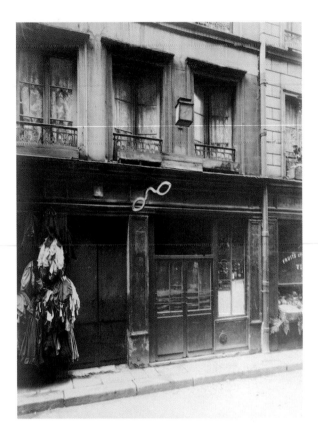

Le cabaret du « Père Lunette », 4 rue des Anglais (5ᵉ arr.), 1902

Page | Page | Seite: 107
Magasin de vêtements pour enfants | Children's outfitter | Geschäft für Kinderbekleidung
Avenue des Gobelins (13ᵉ arr.), 1925

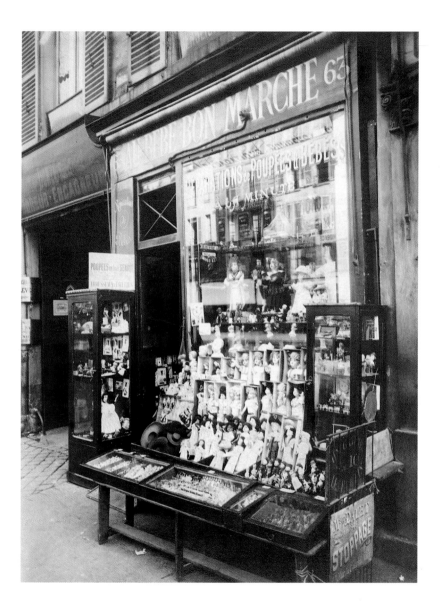

« Au Bébé Bon Marché », 63 rue de Sèvres (7ᵉ arr.), 1911
Boutique de jouets | Toyshop | Spielwarenladen

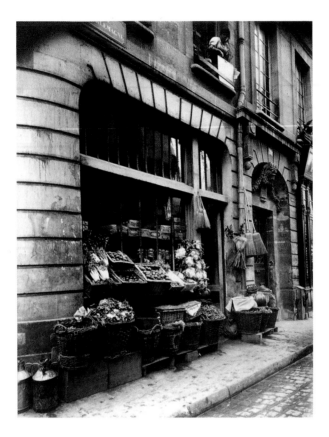

Boutique | Shop | Geschäft
25 rue Charlemagne (4ᵉ arr.), 1911

Boutique de fruits et légumes | Fruit and vegetable shop | Obst- und Gemüsegeschäft
Rue Mouffetard (5ᵉ arr.), 1925

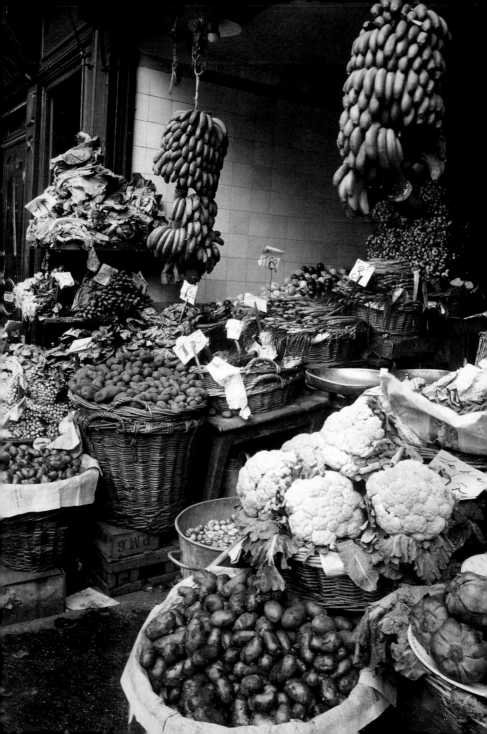

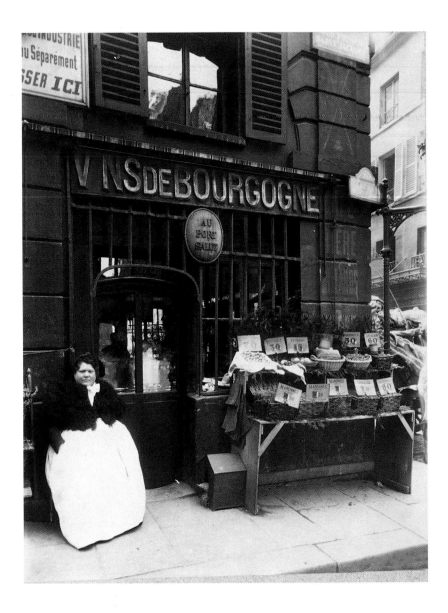

Cabaret « Au Port-Salut »
163 bis rue des Fossés-Saint-Jacques (5e arr.), 1903

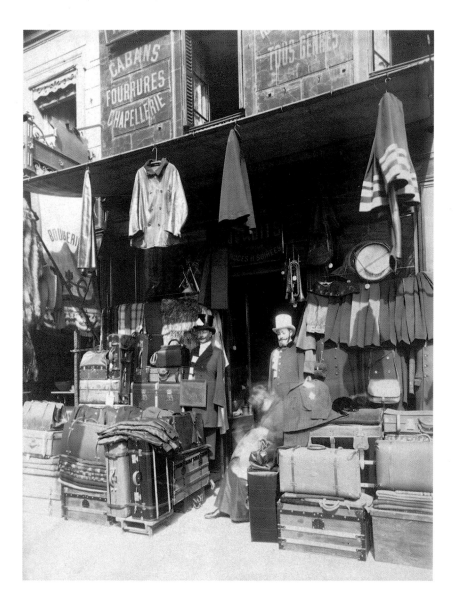

Boutique d'articles pour hommes | Menswear accessory shop | Geschäft für Herrenaccessoirs
16 rue Dupetit-Thouars (3e arr.), 1910

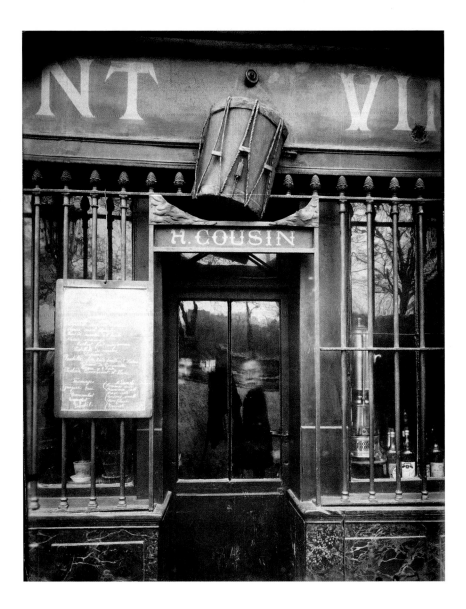

« Au Tambour », 63 quai de la Tournelle (5ᵉ arr.), 1908

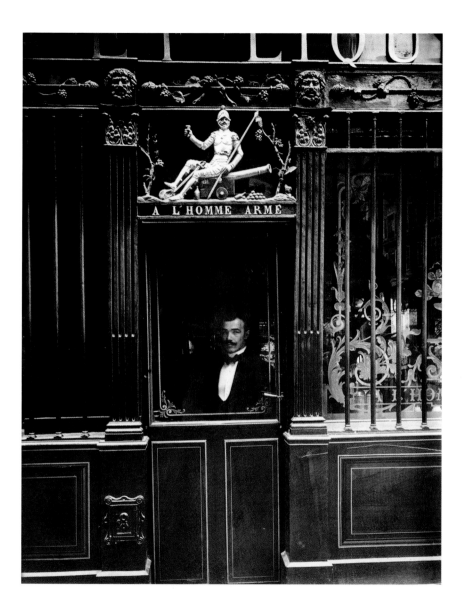

Café « A l'Homme Armé », 25 rue des Blancs-Manteaux (4e arr.), 1900

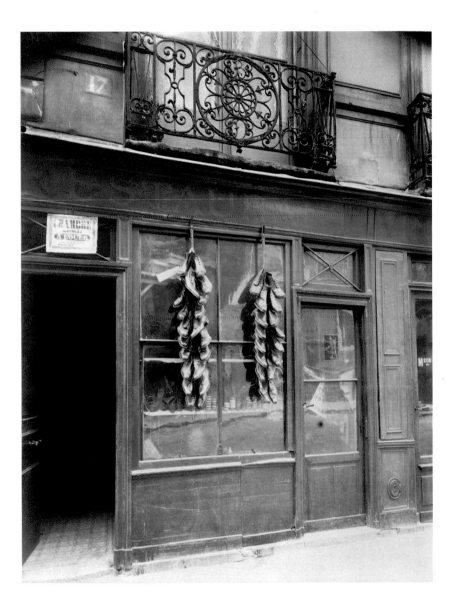

Enseigne et balcon | Shop sign and balcony | Werbeschild und Balkon
17 rue du Petit-Pont (5e arr.), 1913

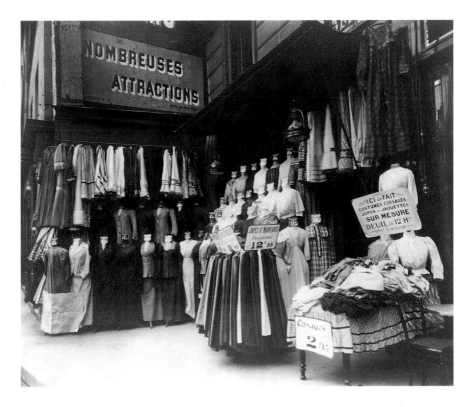

Boutique | Shop | Geschäft
61 rue Au Maire (3e arr.), 1911

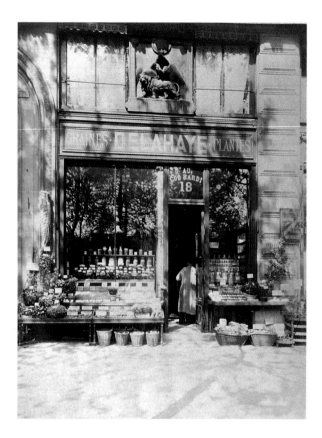

« Au Coq Hardi », 18 quai de la Mégisserie (1^{er} arr.), 1902

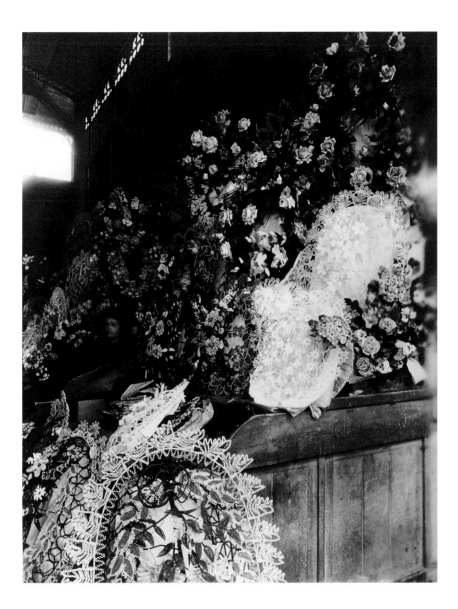

Les Halles (1ᵉʳ arr.), 1911

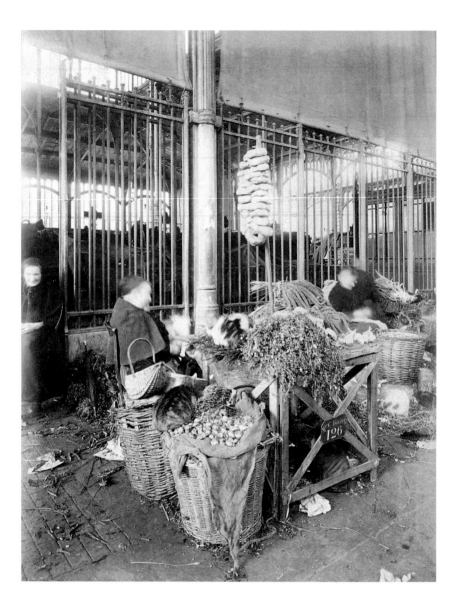

Les Halles (1er arr.), septembre 1900

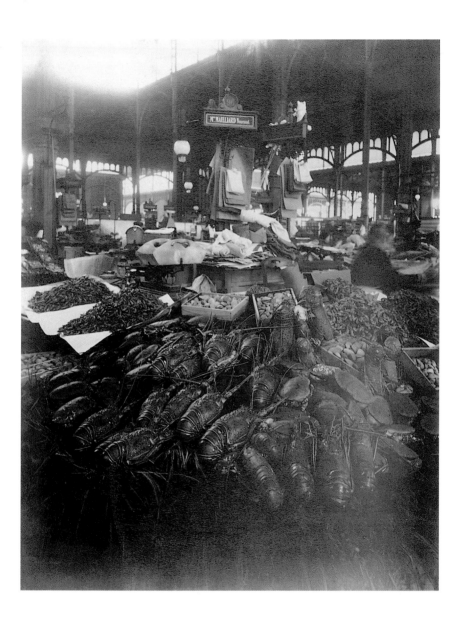

« Maison Mailliard », Les Halles (1ᵉʳ arr.), 1911

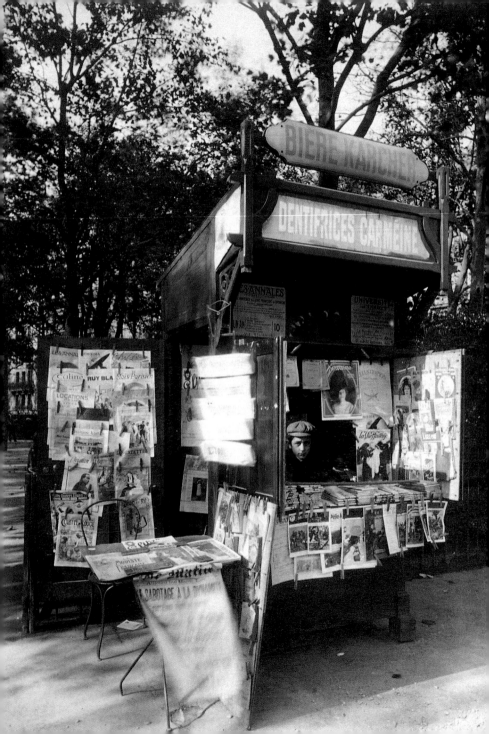

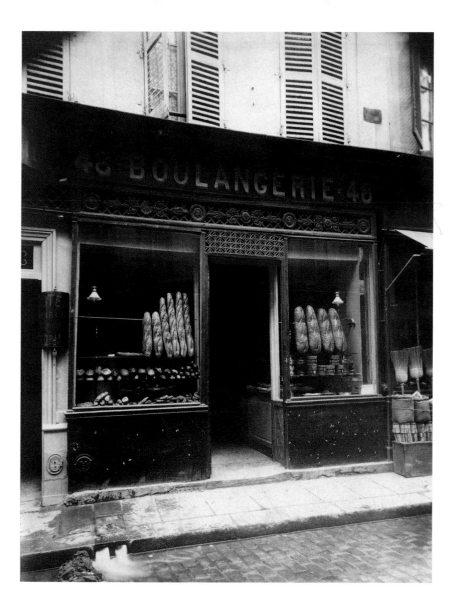

Boulangerie | Baker's shop | Bäckerei
48 rue Descartes (5ᵉ arr.), 1911

Kiosque à journaux | Newspaper kiosk | Zeitungskiosk
Square Potain, rue de Sèvres (7ᵉ arr.), 1911

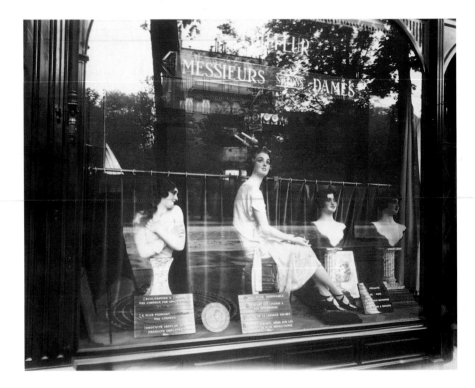

Coiffeur | Hairdresser | Friseur
Avenue de l'Observatoire (14e arr.), 1926

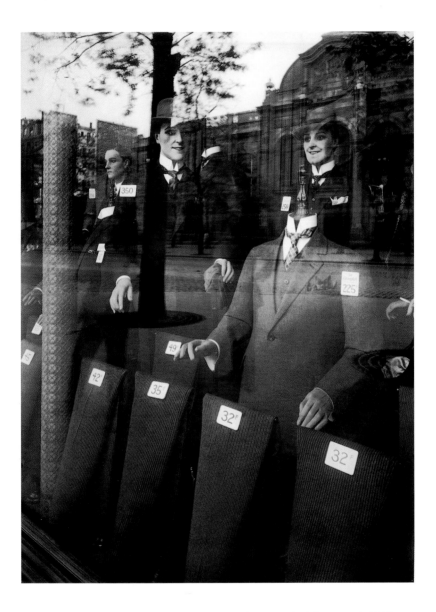

Magasin de vêtements pour hommes | Menswear shop | Geschäft für Herrenbekleidung
Avenue des Gobelins (13ᵉ arr.), 1926

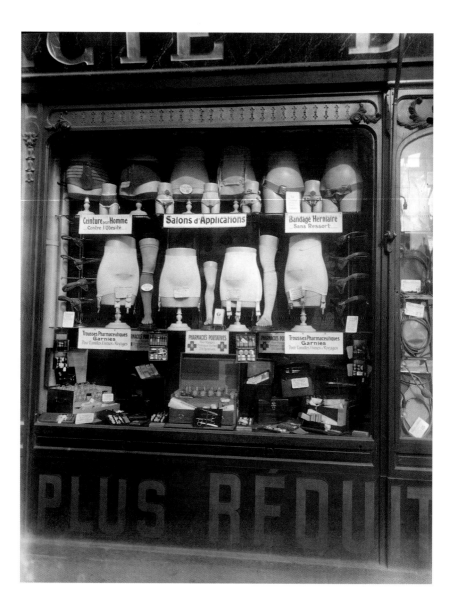

Boutique | Shop | Geschäft
Boulevard de Strasbourg (10e arr.), 1921

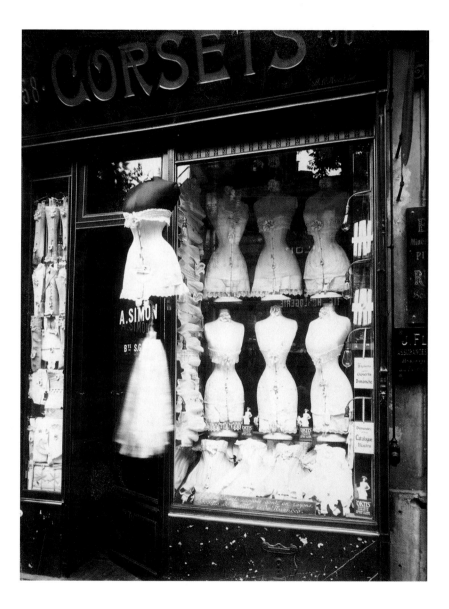

Corsets | Corsets | Korsetts
Boulevard de Strasbourg (10ᵉ arr.), 1921

Véhicules
à Paris

La Voiture
à Paris

Fahrzeuge
in Paris

EUGÈNE ATGET

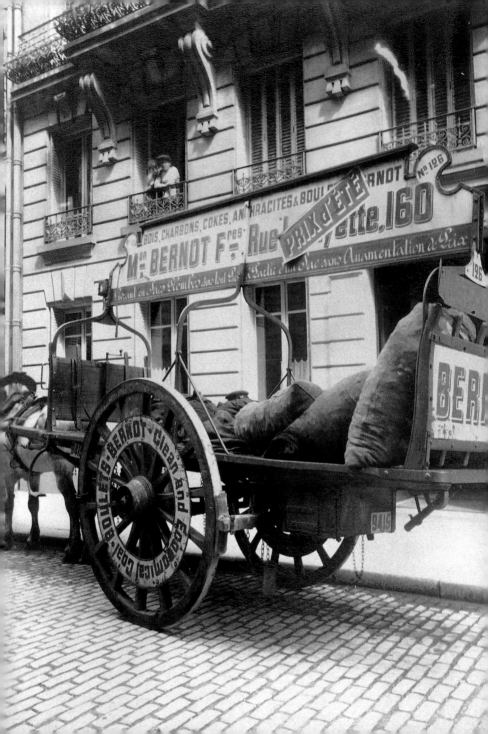

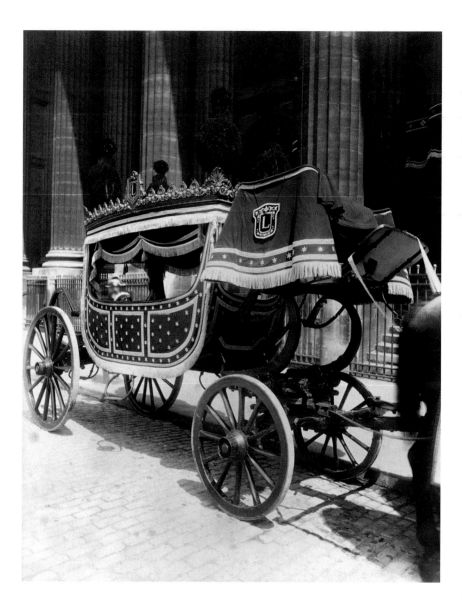

Corbillard de pompes funèbres 1ʳᵉ classe | First-class hearse | Leichenwagen, 1. Klasse
Eglise Saint-Sulpice (6ᵉ arr.), 1910

Page | Page | Seite: 129
Voiture des charbons Bernot | Bernot coal cart | Bernot Kohlenwagen, 1910

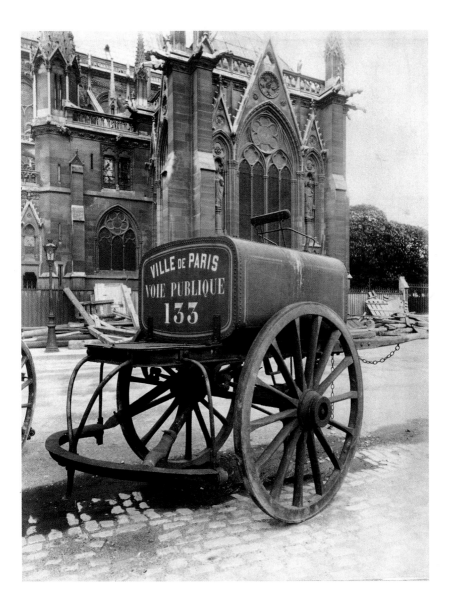

Voiture d'arrosage de la Ville de Paris | Water cart | Wassersprengwagen,
près de Notre-Dame, 1910

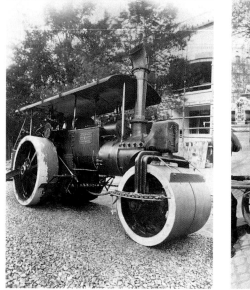

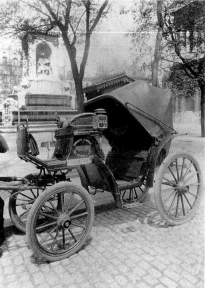

Voiture à broyer les pierres
Steamroller
Dampfwalze, 1910

Fiacre à pneu plein | Solid-tyred cab
Droschke mit Vollgummireifen
Place Saint-Sulpice (6ᵉ arr.), 1910

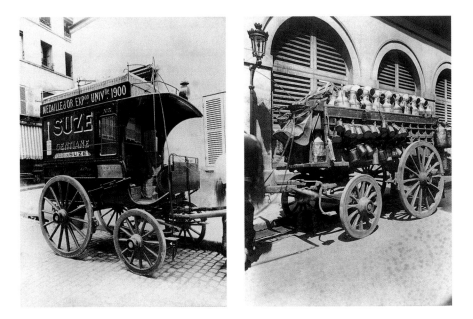

Voiture de distillateur
Distiller's cart
Wagen eines Branntweinbrenners, 1910

Voiture de laitier
Dairy cart
Milchwagen, 1910

Camion de chemin de fer de l'Etat | Haulage cart wagon
Transportwagen der Eisenbahn, 1910

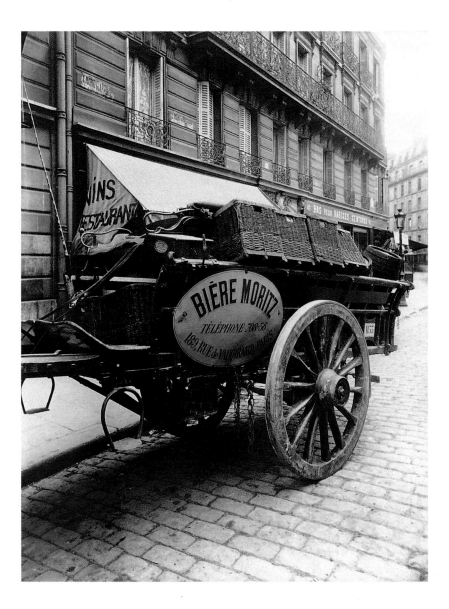

Voiture de brasseur | Brewer's cart
Brauereiwagen, 1910

The Inhabitants
of the Paris
Suburby Toward

*Zoniers
de Paris*

Bewohner
der Pariser
Außenbezirke

EUGÈNE ATGET

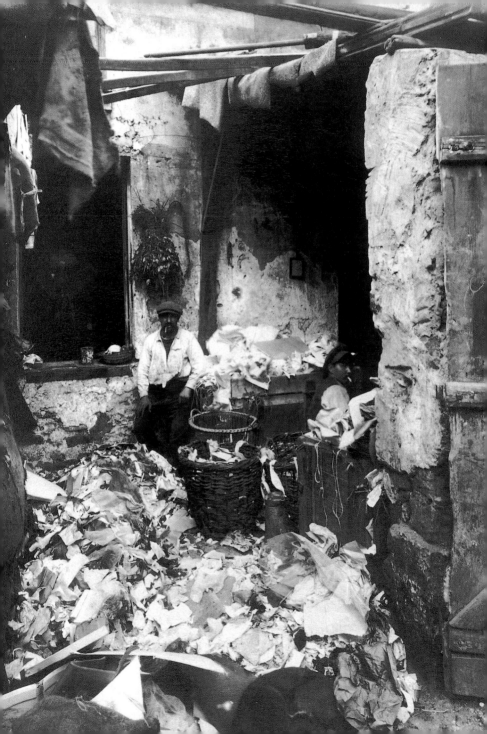

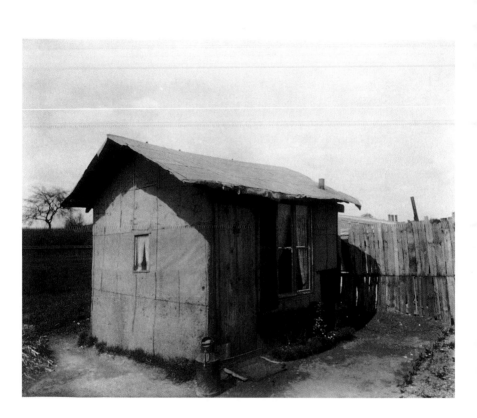

Porte d'Ivry extra-muros (13ᵉ arr.), 1910

Page | Page | Seite: 137
Chiffonnier | Rag-and-bone man | Lumpensammler
Porte d'Asnières, Cité Trébert (17ᵉ arr.), 1913

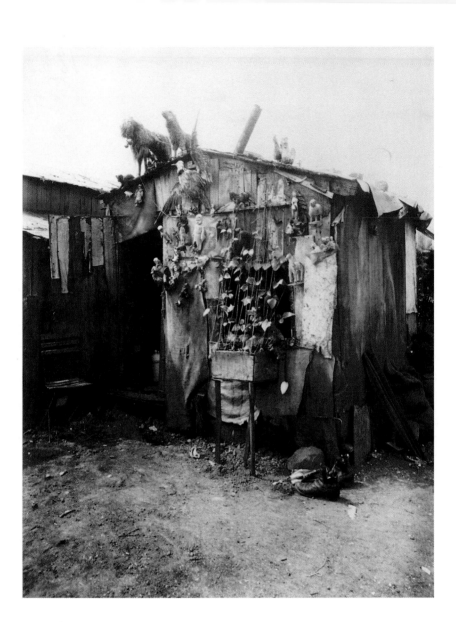

Maison d'un chiffonnier | Rag-and-bone man's house | Haus eines Lumpensammlers
Porte de Montreuil extra-muros (20e arr.), 1910

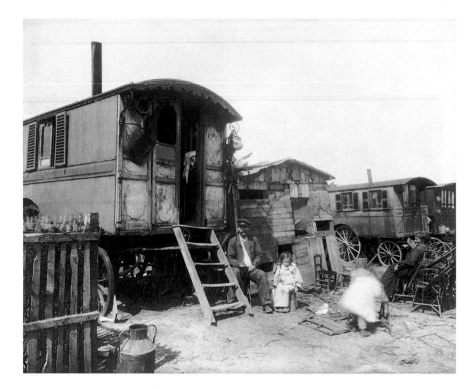

Le village d'Ivry, porte d'Ivry extra-muros (13ᵉ arr.), 1910

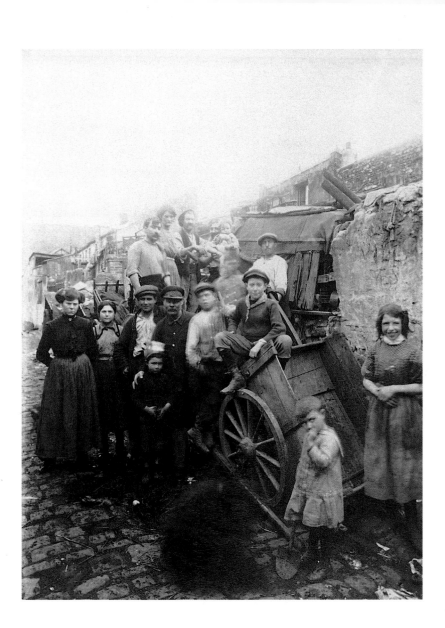

Chiffonniers | Rag-and-bone men | Lumpensammler
Porte d'Asnières, Cité Valmy (17ᵉ arr.), 1913

Musée de
l'érotisme

Maison
close

Freudenhaus

EUGÈNE ATGET

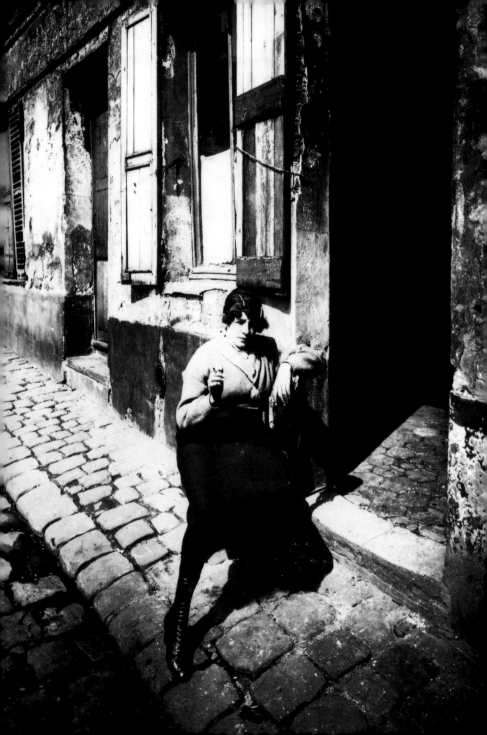

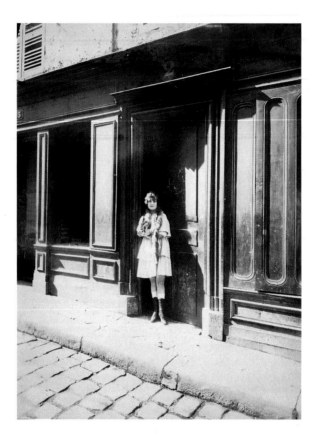

Maison close | House of pleasure | Freudenhaus, Versailles, 1921

Page | Page | Seite: 143
Fille publique faisant le quart | Streetwalker
Prostituierte, La Villette (19e arr.), April 1921, printed c. 1935

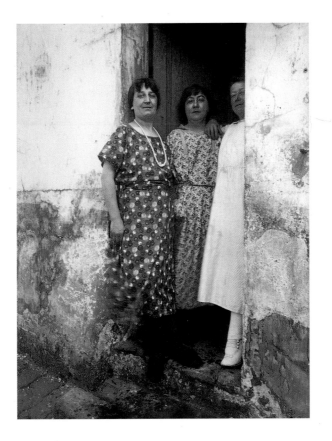

Rue Asselin, aujourd'hui rue H. Torot (19ᵉ arr.), 1924–1926

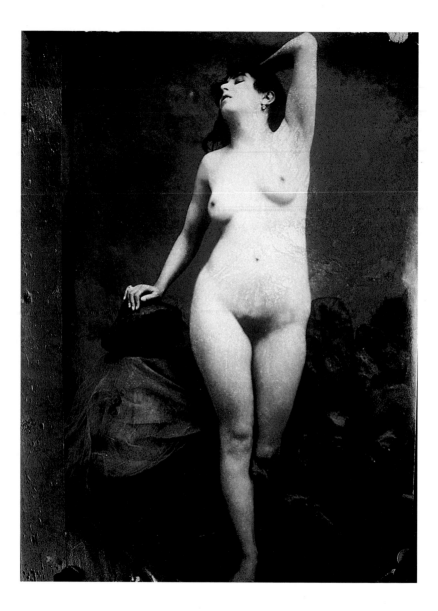

Reproduction d'une photographie de nu, 1920
Reproduction of a photograph of a nude
Reproduktion einer Aktphotographie

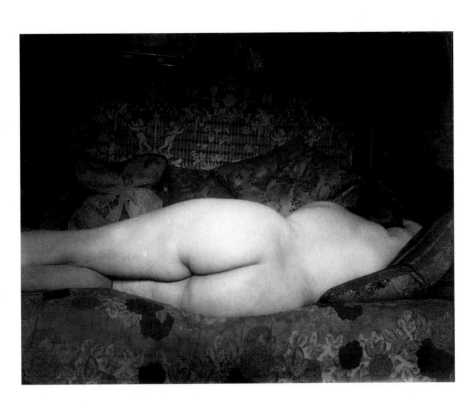

Nu allongé | Reclining nude | Ausgestrecker Akt, c. 1925–1926

EUGÈNE ATGET

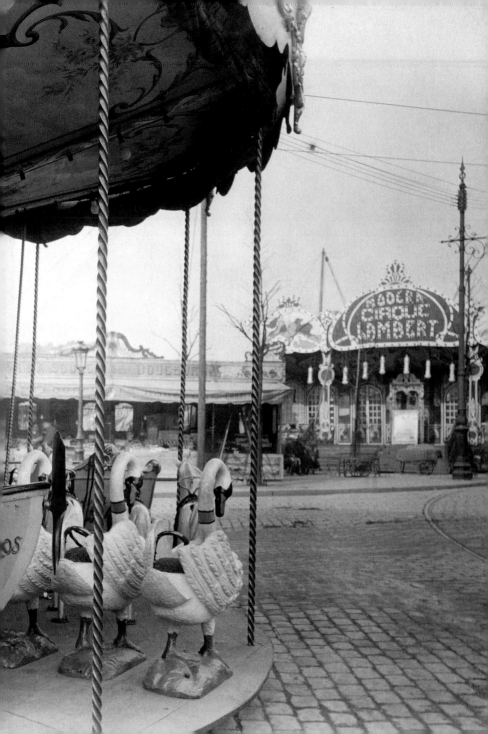

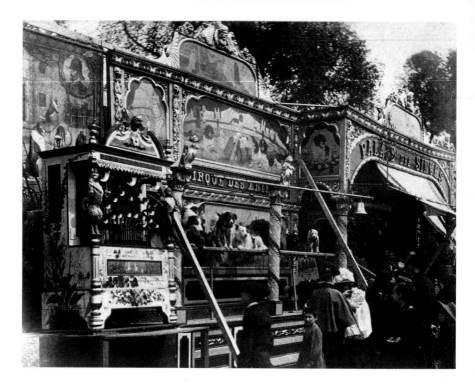

Fête des Invalides, 1898

Page | Page | Seite: 149
Cirque Lambert, Fête de la Villette (détail), 1926

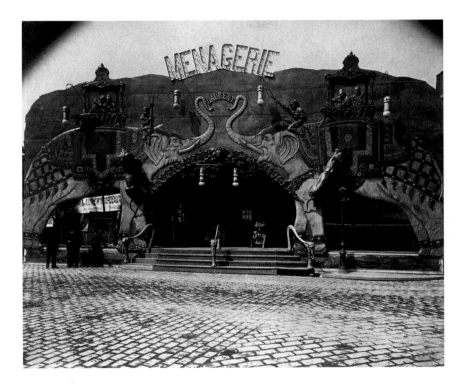

Fête du Trône (20ᵉ arr.), 1914

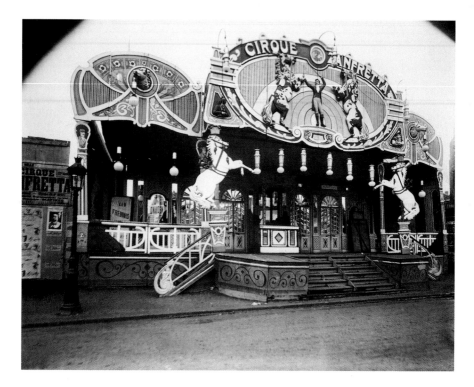

Cirque Zanfretta, Fête de Vaugirard, 1913

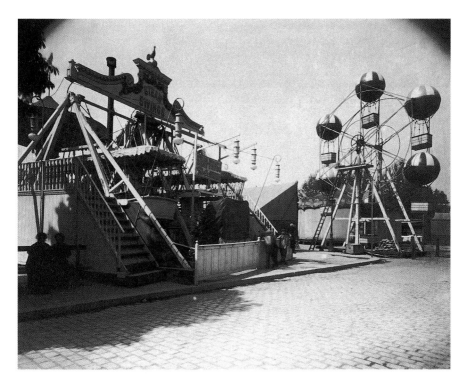

Fête du Trône (20e arr.), 1914

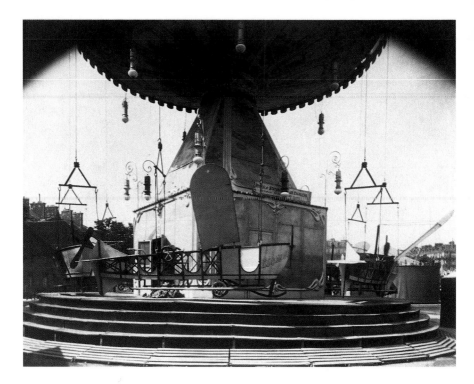

Fête du Trône (20ᵉ arr.), 1914

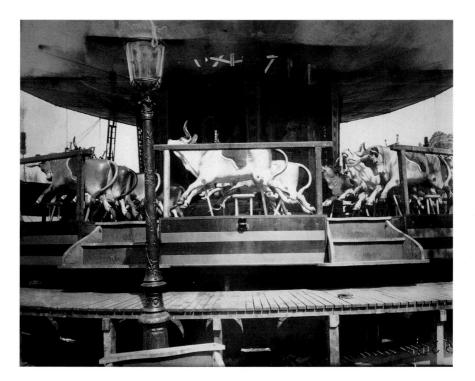

Fête du Trône (20ᵉ arr.), 1925

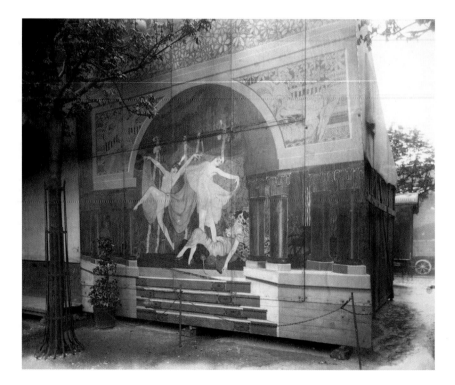

Fête des Invalides, Palais des femmes, 1926

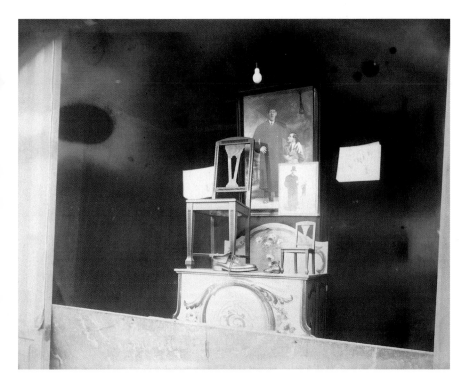

Fête du Trône (20ᵉ arr.), 1925
Le Géant | The giant | Der Gigant

The Outskirts of Paris

Les Environs de Paris

Die nahe Umgebung von Paris

EUGÈNE ATGET

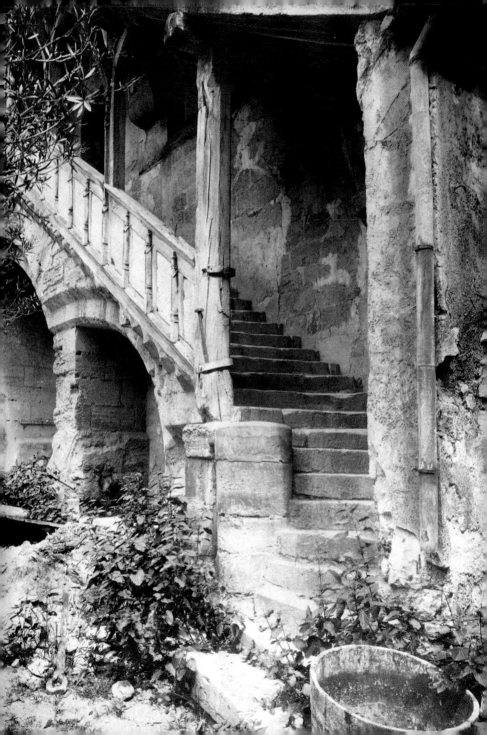

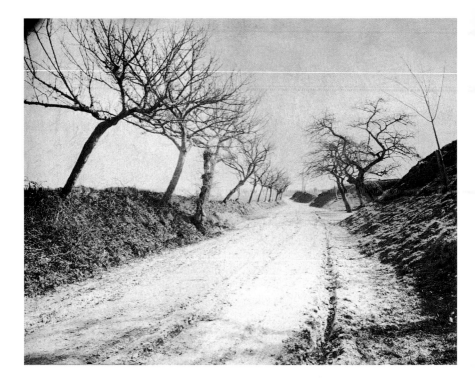

Chemin à travers champs conduisant à la tombe de l'acteur Molé à 2 kms d'Antony, 1902
Country road leading to the tomb of the actor Molé, 2 km from Antony, 1902
Weg zum Grab des Schauspielers Molé, 2 km entfernt von Antony, 1902

Page | Page | Seite: 159
Ancien cloître des Chanoines | Former canon's cloister | Ehemaliges Kanonikerkloster
Meaux, 1910

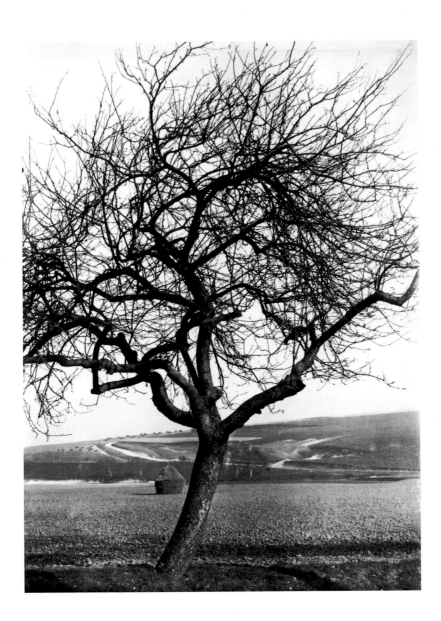

Pommier | Apple tree | Apfelbaum, 1900

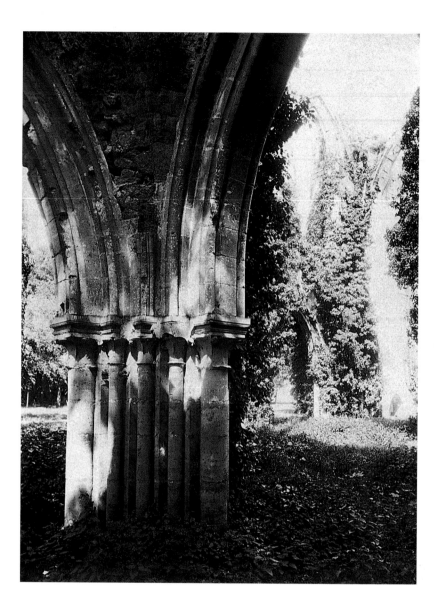

Dammarie-les-Lys, ruines de l'Abbaye du Lys, 1910

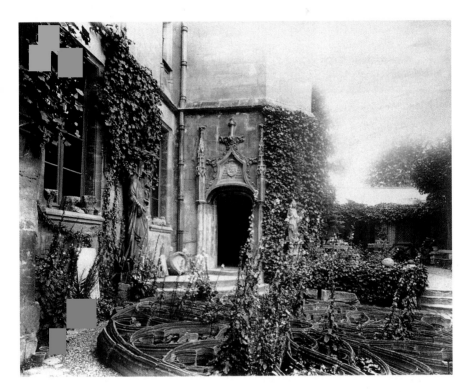

Pontoise, ancien Palais du Tribunal, musée, 1902

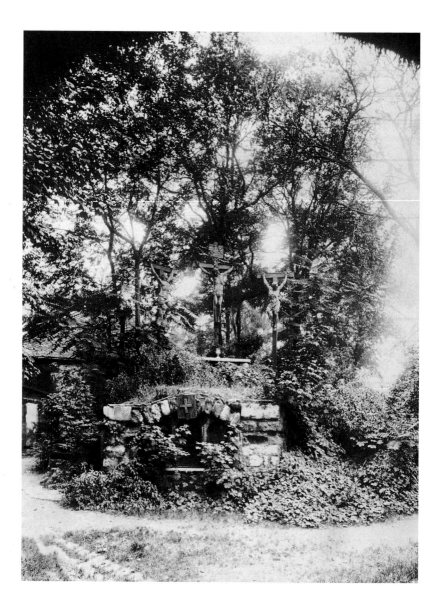

Calvaire | Cavalary | Kalvarienberg
Eglise Saint-Pierre-de-Montmartre (18ᵉ arr.), août 1899

Parc de Saint-Cloud, 1906

Parks
and
Castles

*Jardins
et châteaux*

Gärten
und
Schlösser

EUGÈNE ATGET

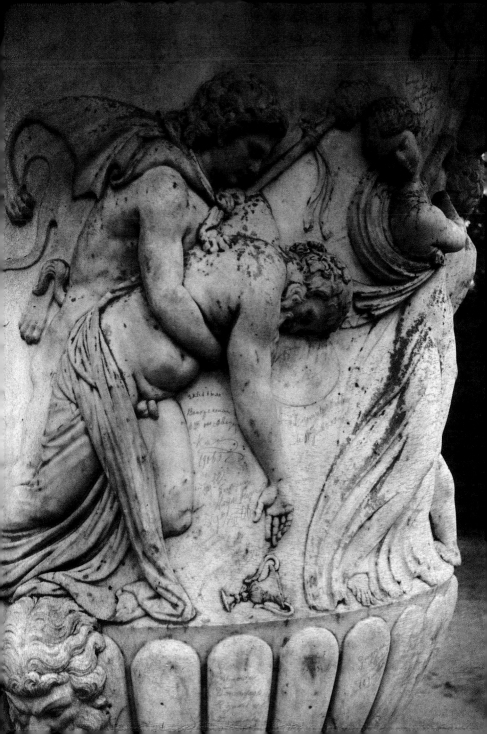

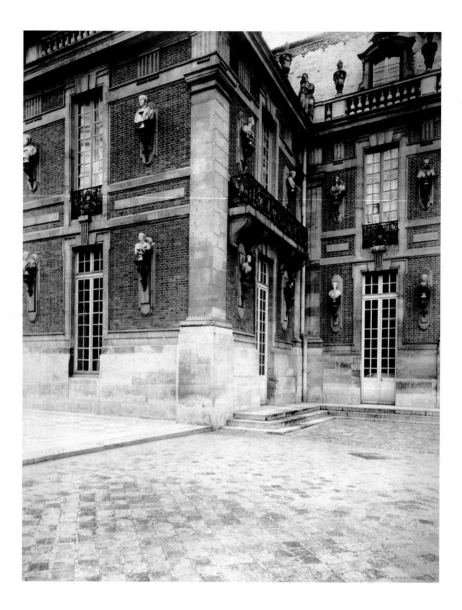

Versailles, cour royale, 1902

Page | Page | Seite: 167
Versailles, parterre de Latone
Cornu: copie de vase Borghèse (détail), 1906

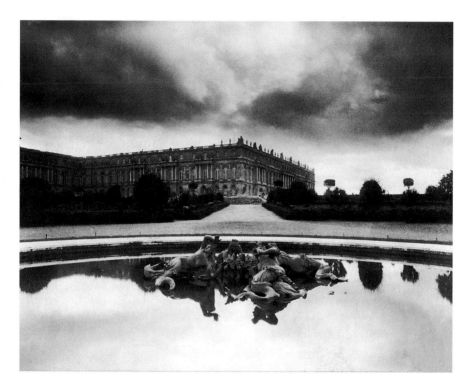

Versailles, parterre du Nord, bassin des Sirènes, fin octobre 1903

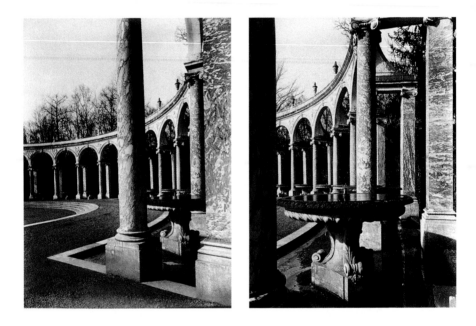

Versailles, bosquet de la Colonnade, 1904 Versailles, bosquet de la Colonnade, 1904

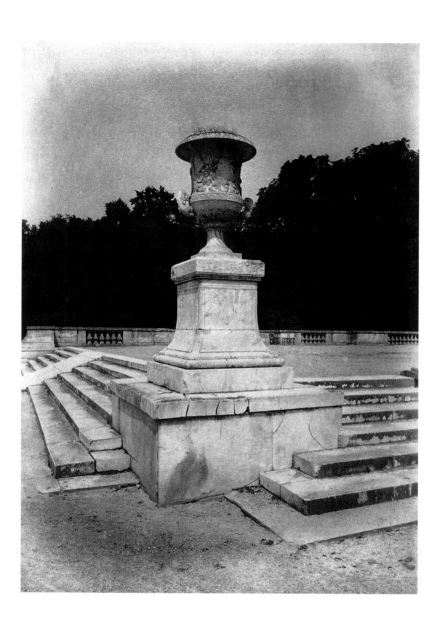

Versailles, parterre du Midi, le Château
Bertin: Vase, 1905

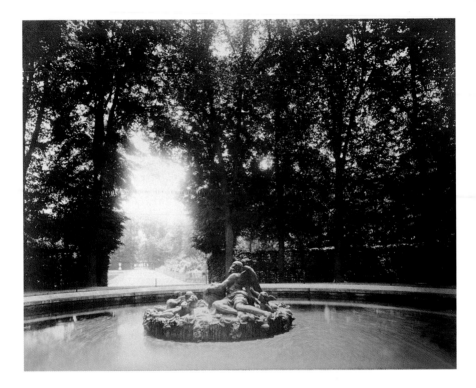

Versailles, coin de parc, 1901
Girardon: Bassin de Saturne

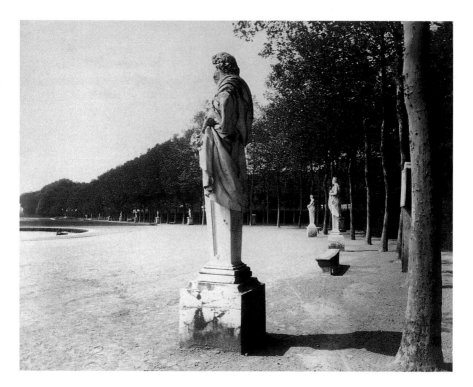

Versailles, 1902
Clérion: Jupiter et Junon | Jupiter and Juno | Jupiter und Juno

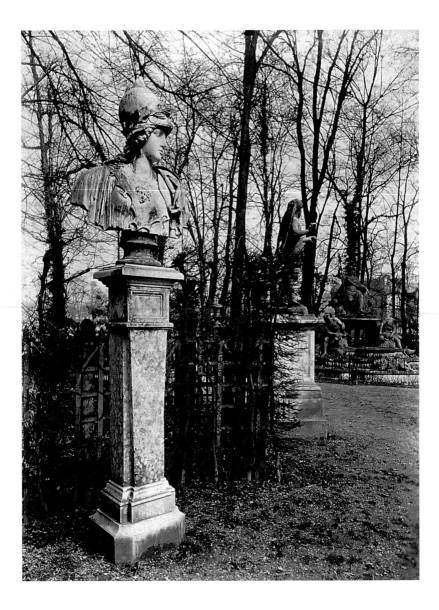

Versailles, bosquet de l'Arc de Triomphe, 1904

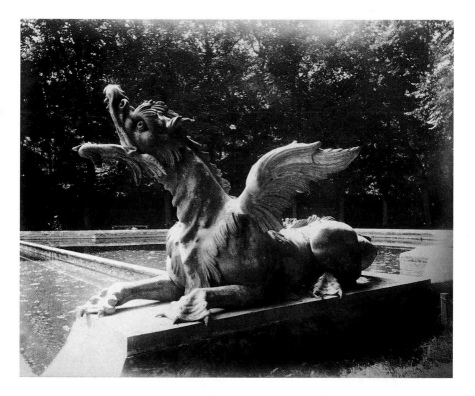

Versailles, Grand Trianon, 1901
Hardy: Dragon | Dragon | Drache

Parc de Saint-Cloud, terrasse du Château, c. 1921–1922

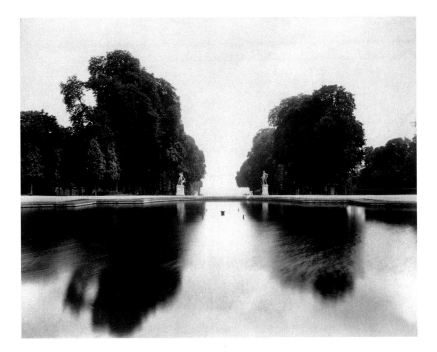

Parc de Saint-Cloud, bassin de la Petite Gerbe, 1904

Biographie
Biography

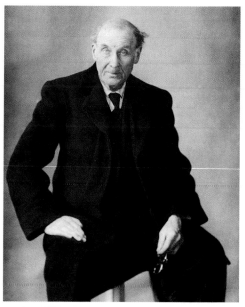

1857

Naissance le 12 février à Libourne (Gironde) de Jean-Eugène-Auguste Atget, fils du charron Jean-Eugène Atget et de Clara-Adeline, née Hourlier.

Jean-Eugène-Auguste Atget born 12 February in Libourne (Gironde), son of the carriage-builder Jean-Eugène Atget and Clara-Adeline, née Hourlier.

Jean-Eugène-Auguste Atget wird am 12. Februar in Libourne (Gironde) als Sohn des Wagenbauers Jean-Eugène Atget und der Clara-Adeline, geb. Hourlier, geboren.

1862

Mort du père, suivie peu de temps après de celle de la mère.

His father dies, followed shortly afterwards by his mother.

Tod des Vaters; wenig später stirbt auch die Mutter.

1862–1878

Atget est élevé par ses grands-parents à Bordeaux, où il reçoit une bonne formation scolaire. Il s'embarque ensuite comme mousse dans la marine marchande.

Atget is brought up by his grand-parents in Bordeaux, and receives a good secondary education. Goes to sea as a ship's boy in the merchant navy.

Atget wächst bei den Großeltern in Bordeaux auf und erhält eine gute Schulbildung. Anschließend fährt er als Schiffsjunge bei der Handelsmarine zur See.

1878

Atget s'installe à Paris où il cherche d'abord, mais en vain, à entrer dans la classe d'Art Dramatique du prestigieux Conservatoire National de Musique et de Déclamation. Il est ensuite obligé de faire son service militaire.

Settles in Paris. Fails entrance exam to the Drama Class of the Conservatoire Nationale de Musique et de Déclamation. Called up for military service.

Atget geht nach Paris und bewirbt sich zunächst vergeblich am angesehenen Conservatoire Nationale de Musique et de Déclamation für das Fach Schauspiel. Er wird zur Ableistung des Wehrdienstes verpflichtet.

1879

Il repasse le concours d'entrée au Conservatoire et le réussit. Mais son service militaire l'empêche de suivre ses études de façon continue.

Passes the entrance exam for the Conservatoire. But military service prevents full-time study.

Eine zweite Bewerbung am Conservatoire hat Erfolg. Atget kann sein Studium wegen des Wehrdienstes nur nebenher betreiben.

1881

Il est renvoyé pour prestations insuffisantes. Avec la mort de ses grands-parents, Atget perd en même temps sa dernière famille proche.

Fails to meet academic standards at the Conservatoire, and is expelled. With the death of his grandparents, he loses the last of his immediate family.

Exmatrikulation wegen ungenügender Leistungen. Durch den Tod seiner Großeltern verliert Atget auch seine letzten nahen Angehörigen.

1882–1887

Atget vit à Paris, au 12 de la rue des Beaux-Arts. Il devient comédien dans une troupe ambulante qui se produit dans la banlieue parisienne et en province. Il fait la connaissance d'André Calmettes, le futur directeur du théâtre de Strasbourg qui devait par la suite faire partie de ses mécènes et procéder, à sa mort, à la partition

Atget lives in Paris, at 12 rue des Beaux-Arts. Joins a group of travelling players, who perform in the Paris suburbs and the provinces. Meets André Calmettes, future Director of the Strasbourg Theatre. Later a patron of Atget's, Calmette administered the artist's *oeuvre* after his death. Atget meets Valentine Delafosse

Atget lebt in Paris, rue des Beaux-Arts 12. Er wird Schauspieler in einer Wandertruppe, die in den Vororten von Paris und in der Provinz auftritt. Er lernt André Calmettes kennen, den zukünftigen Direktor des Straßburger Theaters, der später zu seinen Förderern gehören sollte und nach seinem Tod die Aufteilung des Nachlasses

Carte de visite d'Atget, 1899
Atget's visiting card
Atgets Visitenkarte

Carte de visite d'Atget, 1902
Atget's visiting card
Atgets Visitenkarte

179

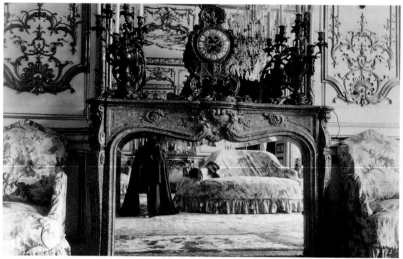

EUGÈNE ATGET,
Hôtel de Matignon,
57 rue de Varenne (8ᵉ arr.),
1905 (détail)

de son œuvre posthume.
Atget rencontre Valentine
Delafosse Compagnon, elle-
même issue d'une vieille
famille de comédiens, qui
sera sa compagne pendant
plus de trois décennies et
emménagera chez lui en
1902.

Compagnon, daughter of a
theatrical dynasty. They have
been lovers for three decades
when she moves in with him
in 1902.

übernehmen wird. Atget
begegnet der aus einer alten
Schauspielerfamilie stam-
menden Valentine Delafosse
Compagnon. Sie wird für
mehr als drei Jahrzehnte sei-
ne Lebensgefährtin und
zieht 1902 zu ihm.

1888–1889
Atget cède son domicile pari-
sien pour vivre en province.
Il a abandonné le théâtre en
raison, dit-il, d'une affection
des cordes vocales. Il s'essaie
à la peinture. Il réalise ses
premières photographies,
des motifs d'Amiens et de
Beauvais.

Sells his Paris residence and
moves to the provinces. He
has given up acting, sup-
posedly because of a laryn-
geal complaint. Tries his
hand at painting. Takes his
first photographs, in Amiens
and Beauvais.

Atget gibt seinen Pariser
Wohnsitz auf und zieht in
die Provinz. Die Schauspie-
lerei hat er – nach eigener
Aussage wegen einer Stimm-
banderkrankung – aufgege-
ben. Er versucht sich als
Maler. Die ersten Photogra-
phien mit Motiven aus Ami-
ens und Beauvais entstehen.

1890

Retour à Paris, au 5 de la rue de la Pitié. Atget ne connaît aucun succès en tant que peintre et décide de devenir photographe. Il réalise alors des « documents » pour des artistes et des artisans. Séjours temporaires dans les départements de la Somme et de l'Oise.

Again in Paris, living at 5 rue de la Pitié. Having failed as a painter, Atget decides to become a photographer. Takes photos as 'documents' for artists and craftsmen. Spends time in the Somme and Oise départements.

Rückkehr nach Paris, die neue Adresse lautet Rue de la Pitié 5. Als Maler erfolglos, entscheidet Atget sich für den Photographenberuf. Es entstehen photographische Vorlagen für Künstler und Kunsthandwerker. Zeitweilige Aufenthalte in den Départements Somme und Oise.

1897

Atget s'oriente de plus en plus vers le recensement photographique de sujets urbains et architecturaux.

Urban and architectural subjects in old Paris form an increasing part of his work.

Atget wendet sich verstärkt der photographischen Erfassung von Stadt- und Architektursujets zu.

1898

Premières ventes de photographies à des collections publiques telles que le musée Carnavalet et la Bibliothèque Historique de la Ville de Paris. Début de l'élaboration de la série des « Petits métiers ».

First sale of photos to public collections such as the Musée Carnavalet and the Bibliothèque Historique de la Ville de Paris. Begins his "Petits métiers" series.

Erste Verkäufe von Photographien an öffentliche Sammlungen wie das Musée Carnavalet und die Bibliothèque Historique de la Ville de Paris. Atget beginnt, die Serie „Petits Métiers" zu erarbeiten.

1899

Atget emménage à Montparnasse, au 17 bis de la rue Campagne-Première, où il installe également son laboratoire et ses archives.

Moves to 17 bis rue Campagne-Première (Montparnasse), where he sets up his darkroom and archive.

Atget zieht in die Wohnung in der Rue Campagne-Première 17 bis am Montparnasse, in der er auch Labor und Archiv einrichtet.

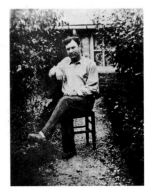

ANONYME
Eugène Atget

1901/1902

Seul voyage connu en Suisse, à Berne et Lucerne, pour y réaliser vraisemblablement des travaux de commande.

Only recorded trip to Switzerland, to Berne and Lucerne, presumably to carry out commissions there.

Einzige bekannte Reise von Atget in die Schweiz, wahrscheinlich wegen Auftragsarbeiten in Bern und Luzern.

1901–1907

Atget commence à mettre au point sa série sur « L'Art dans le Vieux Paris » et ne cesse d'enrichir au fil des ans son répertoire de sujets et de motifs. S'ajoutent désormais à sa clientèle des décorateurs de théâtre et des architectes.

Les bibliothèques parisiennes les plus importantes, de même que des institutions chargées de l'entretien des monuments et des musées, acquièrent des portfolios assez conséquents. Atget photographie des éléments de décoration architecturale tels que des balcons, des portes ou des escaliers et se rend à cet effet dans les environs de Paris, parcourant parfois un périmètre assez étendu.

Starts his series "L'Art dans le Vieux Paris", over the next few years constantly enriching his repertory of themes and motifs. His clients now include stage-designers and architects.

Substantial collections of Atget's work are bought by major Paris libraries, museums, and institutions for the preservation of historic monuments. Atget photographs decorative architectural features such as balconies, doors, and staircases, sometimes working outside the boundaries of the city.

Atget beginnt mit der Zusammenstellung der Serie „L'Art dans le Vieux Paris" und weitet in den folgenden Jahren sein Themen- und Motivrepertoire ständig aus. Zu seinem Kundenkreis zählen nun auch Bühnenbildner und Architekten. Die wichtigsten Pariser Bibliotheken, Institutionen der Denkmalpflege und Museen erwerben größere Konvolute. Atget photographiert dekorative Architekturelemente wie Balkons, Türen und Treppen und reist zu Aufnahmen in die nähere und weitere Umgebung von Paris.

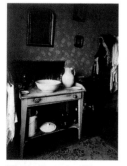

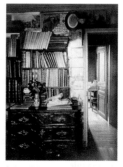

Chambre à coucher d'Atget, c. 1910
Atget's Bedroom
Das Schlafzimmer Atgets

Salon d'Atget, c. 1910
Atget's Salon
Atgets Salon

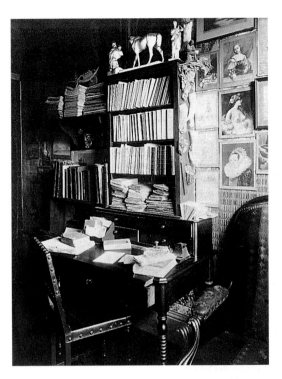

Salon d'Atget, c. 1910
Atget's Salon
Atgets Salon

1906/1907

Atget est chargé par la
Bibliothèque Historique de
la Ville de Paris de documen-
ter systématiquement les
anciennes constructions du
centre-ville et s'inspire pour
cela du très populaire *Guide
pratique à travers le Vieux Paris*
du marquis de Rochegude.

1904–1913

Atget, qui se dit toujours
officiellement « artiste dra-
matique » et « ex-artiste des

Accepts a commission from
the Bibliothèque Historique
de la Ville de Paris to make a
systematic photographic
record of old buildings in
the city centre; to do so, he
makes use of the very popu-
lar *Guide pratique à travers le
Vieux Paris* by the Marquis de
Rochegude.

Atget still officially describes
himself as an 'actor' and 'ex-
artiste of the Paris theatres',

Atget erhält von der Biblio-
thèque Historique de la Ville
de Paris den Auftrag, syste-
matisch die alten Bauwerke
in der Pariser Innenstadt zu
dokumentieren, und orien-
tiert sich hierbei an dem
populären Stadtführer *Guide
pratique à travers le Vieux Paris*
des Marquis de Rochegude.

Atget, der sich offiziell
immer noch als „artiste dra-
matique" und „ex-artiste des

théâtres de Paris », tient des
conférences sur l'histoire du
théâtre et lit des extraits du
répertoire dramatique dans
des universités populaires.

1910–1915
Constitution de plusieurs
albums thématiques qui
sont acquis par le musée
Carnavalet et la Biblio-
thèque Nationale. Réalisa-
tion des séries des « Métiers,
boutiques et étalages de
Paris » et de « Zoniers. Vue et
types de la zone militaire ».

lecturing in adult-education
centres on the history of the
theatre and giving readings
from stage works.

Completion of several
themed albums bought by
the Musée Carnavalet and
the Bibliothèque Nationale.
The two series "Métiers, bou-
tiques et étalages de Paris"
and "Zoniers. Vue et types de
la zone militaire" are also
from this period.

théâtres de Paris" bezeich-
net, hält an verschiedenen
Volkshochschulen theaterge-
schichtliche Vortrage und
liest aus dramatischen Wer-
ken.

Zusammenstellung mehre-
rer Themenalben, die vom
Musée Carnavalet und der
Bibliothèque Nationale er-
worben werden. Die Serien
„Métiers, boutiques et étala-
ges de Paris" und „Zoniers.
Vue et types de la zone mi-
litaire" entstehen.

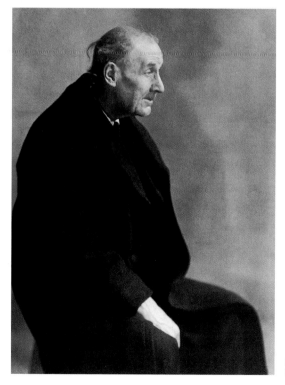

BERENICE ABBOTT
Eugène Atget, 1927

184

1911

Atget vend une collection de journaux d'extrême gauche et d'obédience syndicale à la Bibliothèque Historique de la Ville de Paris.

Atget sells a collection of far-left and trades-union-orientated newspapers to the Bibliothèque Historique de la Ville de Paris.

Atget verkauft der Bibliothèque Historique de la Ville de Paris eine Sammlung ultralinker und gewerkschaftsnaher Zeitungen.

1912

La Bibliothèque Historique de la Ville de Paris critique la qualité de certains tirages. Atget se retire progressivement des affaires courantes.

The Bibliothèque Historique de la Ville de Paris criticises the quality of individual prints. Atget increasingly withdraws from business dealings.

Die Bibliothèque Historique de la Ville de Paris kritisiert die Qualität einzelner Abzüge. Atget zieht sich allmählich vom Alltagsgeschäft zurück.

1917

Atget vend à la Bibliothèque Nationale un dossier de coupures de presse sur l'affaire Dreyfus, qu'il avait constitué entre 1894 et 1902.

Sells the Bibliothèque Nationale a collection of newspaper articles on the Dreyfus affair, compiled between 1894 and 1902.

Atget verkauft der Bibliothèque Nationale eine Sammlung von Zeitungsartikeln über die Affäre Dreyfus, die er von 1894 bis 1902 zusammengestellt hatte.

1914–1918

Atget abandonne presque complètement la photographie. Son activité créatrice connaît une crise profonde, due en partie à la disparition de Léon, le fils de sa compagne, mort au Front. Il entrepose provisoirement ses négatifs dans sa cave pour leur éviter de souffrir de la guerre.

Atget gives up photography almost completely. With the death of Léon, his mistress' son, killed at the front, his creative work suffers. Temporarily moves his negatives to the cellar to protect them from war-damage.

Atget gibt das Photographieren fast vollständig auf. Tiefe Schaffenskrise, auch infolge des Todes von Léon, dem Sohn seiner Lebensgefährtin, an der Front. Das Negativarchiv wird zeitweilig im Keller eingelagert, um es vor Kriegseinwirkungen zu schützen.

1920

Atget vend quelque 2600 plaques au ministère de l'Instruction publique et des Beaux-Arts. Correspondance avec Paul Léon, directeur au ministère du département des Arts plastiques. Atget fait observer qu'avec sa collection, il possède « tout le Vieux Paris ».

Sells c. 2,600 negative plates to the Ministère de l'Instruction publique et des Beaux-Arts. Correspondence with the Ministry's Director of Visual Arts, Paul Léon; Atget notes that, in his collection "he possesses the whole of old Paris".

Atget verkauft ca. 2600 Negative an das Ministère de l'Instruction publique et des Beaux-Arts. Briefwechsel mit dem Direktor der Sektion für Bildende Künste im Ministerium, Paul Léon. Atget weist darauf hin, daß er mit seiner Sammlung „das ganze Alte Paris" besitze.

1921

La Commission des Monuments Historiques de Paris achète 2500 autres négatifs d'Atget et lui procure ainsi

The Commission des Monuments Historiques de Paris buys another 2,500 negatives from Atget. Financially

Die Commission des Monuments Historiques de Paris erwirbt von Atget weitere 2500 Negative. Dadurch

Miniature Camera Work, Photographs by Eugène Atget, New York, 1938

Avant l'Eclipse, place de la Bastille, 17 avril 1912

Les Dernières Conversions
La Révolution surréaliste, no. 7,
15 June 1926.

Intérieurs d'Eglises
Cahier non publié I Unpublished album
Unpublizierte Mappe

L'Art dans le Vieux Paris
Page de titre I Title page
Titelseite, c. 1909

une sécurité financière qui lui permet de renouer avec ses propres projets. C'est probablement à une commande du peintre André Dignimont que répond la réalisation d'une série sur les prostituées.

secure as a result, Atget now returns to his own projects with renewed intensity. He produces a series of images of prostitutes, probably commissioned by the painter André Dignimont.

finanziell abgesichert, wendet sich Atget verstärkt eigenen Projekten zu. Vermutlich im Auftrag des Malers André Dignimont entsteht eine Serie mit Prostituierten.

1921–1925

Atget se remet à photographier les parcs de Versailles et de Saint-Cloud, ainsi que Paris.

Atget returns to photographing the parks of Versailles, Saint-Cloud, and Paris.

Atget photographiert erneut in den Parks von Versailles und Saint-Cloud und in Paris.

1925

Atget découvre au printemps le parc de Sceaux, laissé alors à l'abandon. Sous l'influence de ce que lui en avait dit Man Ray, l'Américaine Berenice Abbott va voir Atget dans son atelier et lui achète ses premières photographies. Elle s'efforce de susciter l'intérêt d'autres artistes pour l'œuvre d'Atget.

In spring, discovers the abandoned Parc de Sceaux. At Man Ray's suggestion, Berenice Abbott visits Atget in his studio, and acquires her first Atget photographs. She seeks to interest other artists in his work.

Atget entdeckt im Frühjahr den verwilderten Park von Sceaux. Die Amerikanerin Berenice Abbott sucht aufgrund eines Hinweises von Man Ray Atget in seinem Atelier auf und erwirbt erste Aufnahmen. Sie bemüht sich, weitere Künstler für das Werk von Atget zu interessieren.

1926

La mort de Valentine Delafosse Compagnon brise définitivement la puissance créatrice d'Atget. Man Ray fait imprimer quatre photographies d'Atget dans la revue *La Révolution surréaliste*.

The death of Valentine Delafosse Compagnon marks the end of Atget's creative life. Man Ray has four of Atget's photographs printed in the journal *La Révolution surréaliste*.

Der Tod von Valentine Delafosse Compagnon bricht Atgets Schaffenskraft endgültig. Man Ray veranlasst in der Zeitschrift *La Révolution surréaliste* den Abdruck von vier Photographien Atgets.

1927

Berenice Abbott fait venir Atget dans son propre atelier pour le photographier. Au terme d'une interruption de plusieurs mois, celui-ci se remet à la photographie au printemps. Eugène Atget meurt le 4 août 1927 à Paris, des suites d'une brève maladie.
Son exécuteur testamentaire André Calmettes remet environ 2000 négatifs à la Com-

Berenice Abbott takes a portrait of Atget in her studio. In the spring, for the first time in several months, he returns to photography. Dies 4 August 1927 in Paris, after a short illness.
The executor of Atget's estate, André Calmettes, gives some 2,000 negatives to the Commission des Monuments Historiques de Paris. With financial assistance

Atget wird von Berenice Abbott in ihrem Atelier porträtiert. Er beginnt nach mehrmonatiger Pause im Frühjahr wieder zu photographieren. Nach kurzer Krankheit stirbt Eugène Atget am 4. August 1927 in Paris.
André Calmettes übergibt als Nachlassverwalter ungefähr 2000 Negative an die Commision des Monuments

mission des Monuments Historiques de Paris. Avec le soutien financier de Julien Levy, Berenice Abbott acquiert les 1300 négatifs restants et quelque 5000 épreuves.

from Julien Levy, Berenice Abbott acquires the remaining 1,300 negatives and approximately 5,000 prints.

Historiques de Paris. Berenice Abbott erwirbt, mit finanzieller Unterstützung von Julien Levy, die verbleibenden 1300 Negative und etwa 5000 Abzüge.

1928
Plusieurs photographies d'Atget, qui proviennent vraisemblablement de la collection de Man Ray, sont exposées au « Premier Salon des Indépendants de la Photographie ».

At the "Premier Salon des Indépendants de la Photographie" in Paris a number of photographs by Atget, probably from Man Ray's collection, are shown.

Im „Premier Salon des Indépendants de la Photographie" in Paris werden mehrere Photographien von Atget ausgestellt, die wahrscheinlich aus der Sammlung von Man Ray stammen.

1929
11 photographies d'Atget, appartenant à Berenice Abbott, sont montrées à la légendaire exposition « Film und Foto » de Stuttgart.

Eleven Atget photographs owned by Berenice Abbott are exhibited at the epoch-making exhibition "Film und Foto" in Stuttgart.

In der epochalen Ausstellung „Film und Foto" in Stuttgart werden elf Atget-Photographien aus dem Besitz von Berenice Abbott gezeigt.

1930
Parution à Paris, Leipzig et New York du livre Atget. Photographe de Paris, qui donne pour la première fois un aperçu de l'ensemble de son œuvre.

The book Atget. Photographe de Paris, published in Paris, Leipzig and New York, provides the first overview of his work.

Das Buch Atget. Photographe de Paris erscheint in Paris, Leipzig und New York und gibt erstmals einen Überblick über sein Werk.

1968
Avec la vente de la collection Abbott/Levy au Museum of Modern Art de New York s'ouvre une phase très active d'étude et de diffusion de l'œuvre photographique d'Atget.

The sale of the Abbott/Levy collection to the Museum of Modern Art, New York, marks the start of a period of intensive research into Atget's photographs; his work is now increasingly well-known.

Der Verkauf der Sammlung Abbott/Levy an das Museum of Modern Art, New York, eröffnet eine Phase der intensiven Erforschung und Verbreitung von Atgets photographischem Werk.

La cheminée du salon
d'Atget, c. 1910
The Mantel in Atget's Salon
Der Kamin in Atgets Salon

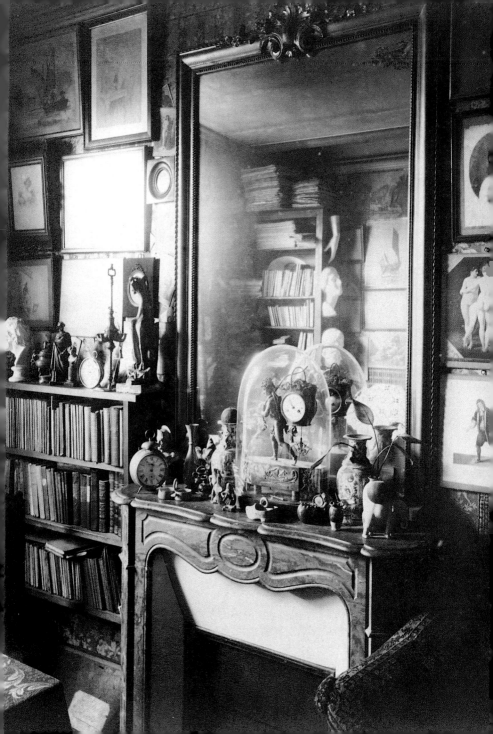

Crédits photographiques
Photographic credits
Bildnachweis

l. = à gauche | left | links
r. = à droite | right | rechts
t. = ci-dessus | top | oben
b.= ci-dessous | bottom | unten

Page | Seite

Bibliothèque Historique de la Ville de Paris:

2 XXXI, 27 (detail); **4** Divers XXIII, 65; **8** XXII, 135; **9** XX, 236; **10** XXI, 23; **11** XX, 93; **12** XXIV, 168; **13** XXIV, 169; **14** XXII, 56; **15** III, 10; **16** XVII, 88; **17** II, 64; **19** XXI, 358; **37 t. l.** Divers I, 1; **37 t. r.** Divers I, 49; **37 b. l.** Divers I, 12; **37 b. r.** Divers I, 38; **39** Divers I, 69; **40 l.** Divers I, 58; **40 r.** Divers I, 65; **41 l.** Divers I, 50; **41 r.** Divers I, 32; **42** Divers I, 57; **43 l.** Divers I, 54; **43 r.** Divers I, 39; **44** XXII, 46; **45** XXII, 42; **47** XX, 220; **48** XVII, 85; **49** XXI, 26; **50** LXX, 28; **51** LXX, 25; **52** XX, 78; **53** LXIX, 71; **54** XXXIII, 8; **55** XXXIII, 6; **56 l.** XIV, 242; **56 r.** XIV, 249; **57** XIV, 34; **58** XIV, 74; **59** XVI, 175; **60** LXII, 8; **64** XX, 440; **65** IX, 42; **66** XXIV, 15; **67** XIV, 54; **68** XVII, 18; **69 l.** XX, 38; **69 r.** XXII, 138; **70** XVII, 32; **71** XXII, 25; **72** XIII, 198; **73** II, 33; **74** XX, 568; **75** II, 32; **76 l.** LXII, 11; **76 r.** LI, 12; **77** LXII, 10; **78** XXII, 51; **79** I, 258; **80** I, 305; **81** I, 341; **82** XXII, 89; **83** XX, 106; **84** XIV, 138; **85** XX, 169; **86** Divers III, 48; **87** XIV, 144; **88** I, 453; **89** XVII, 98; **90** XVI, 110; **92 l.** XI, 118; **92 r.** I, 18; **93** XXIII, 12; **94** XXII, 118; **95** XII, 31; **97** Neuilly-sur-Seine, 3; **98** XXV, 215; **99** XXV, 212; **100 l.** XXIII, 34; **100 r.** Divers XXIII, 33; **102** Divers XXIII, 46; **103** Divers XXIII, 7; **104** XXIII, 53; **105** Divers XXIII, 47; **108** XX, 18; **109** XXIII, 17; **110** XIV, 294; **112** XIX, 16; **113** X, 10;

116 XX, 547; **118** I, 8; **119** II, 161; **120** II, 16; **121** II, 156; **122** XXV, 370; **123** XX, 467; **129** Divers XII, 52; **130** Divers XII, 6; **131** Divers XII, 31; **132 l.** Divers XII, 46; **132 r.** Divers XII, 21; **133 l.** Divers XII, 53; **133 r.** Divers XII, 58; **134** Divers XII, 64; **135** Divers XII, 48; **137** Levallois-Perret, 12; **138** Ivry-sur-Seine, 10; **139** Montreuil, 4; **140** Ivry-sur-Seine, 7; **141** Levallois-Perret, 8; **150** Divers IX, 11; **151** Divers IX, 125; **154** Divers IX, 126; **159** Meaux, 2; **160** Antony, 1; **162** Dammarie-les-Lys, 3; **163** Pontoise, 12; **164** LXX, 6; **165** Saint-Cloud, 106; **167** Versailles, 157; **168** Versailles, 10; **169** Versailles, 27; **170 l.** Versailles, 206; **170 r.** Versailles, 207; **171** Versailles, 135; **172** Versailles, 203; **173** Versailles, 215; **174** Versailles, 48; **175** Versailles, 250; **177** Saint-Cloud, 88; **180** XXV, 212 (detail); **182 l.** Divers XXIII, 43; **182 r** ; **183** Divers XXIII, 59; **186 c. l.** Divers II, 31; **189** Divers XXIII, 56

Centre des Monuments Nationaux, Paris : © ARCH. PHOT. PARIS/CMN
18 MH 38318 N; **35** MH 38526; **61** MH 87005 N; **62** MH 87113 N, **63** MH 87134 N

Collection Gérard Levy, Paris: **175**

International Museum of Photography and Film at George Eastman House, Rochester (New York): Museum Purchase : ex-collection Man Ray :
107 14038 24988 76:0118:0010; **111** 5532 76:0118:0008; **114**; **115**; **124** 11426 76:0118:0018;
125 76:0118:0009; **144** 36504 4160 76:0118:0001; **145** 5873 76:0118:0004; **146** 20801 76:0118:0005; **147** 6114 76:0118:0006; **149** 5869 76:0118:0014

(detail); **152** 4163 5529 76:0118:0030; **153** 14037 24989 76:0118:0035; **155** 26845 76:0118:0041; **156** 36181 76:0118:0016; **157** 38416 6113 76:0118:0007

National Gallery of Canada, Ottawa: **143** Acc. 21 109, Gift of Dorothy Meigs Eidlitz, St. Andrews, New Brunswick, 1968; **161** Acc. 21 231, Purchased, 1974; **176** Acc. 21 118, Purchased, 1980

Philadelphia Museum of Art, Philadelphia (Pennsylvania): **184** Gift of Carl Zigrosser

Private Collection: **178, 181**

190

Légendes du portfolio
Portfolio captions
Portfolio Bildlegenden

8| Eglise Saint-Sulpice, rue Férou (6e arr.), 1898

9| Eglise Saint-Etienne-du-Mont, pris de la rue de la Montagne-Sainte-Geneviève (5e arr.), 1898

10| Cour de Rouen ou de Rohan, boulevard Saint-Germain (6e arr.), avril 1898

11| Coin de la rue Saint-Séverin et des nos 4 et 6 rue Saint-Jacques (5e arr.), 1899

12|13 Coin des rues de Seine et de l'Echaudé-Saint-Germain (6e arr.), 1910

14| Oratoire Marie de Médicis Marie de Médici's Oratory Oratorium Maria de Médici Petit Luxembourg, rue de Vaugirard (6e arr.), 1903

15| Palais Royal (1er arr.), 1913

16| Entrée de la cour, 9 rue Thouin (5e arr.), 1910

17| Impasse des Bourdonnais (1er arr.), 1908

18| Rue des Ursins (4e arr.), 1900

19| Ancien passage du Pont-Neuf, aujourd'hui rue Jacques Callot, (6e arr.), 1913

Front and back cover:
Le Moulin-Rouge,
86 boulevard de Clichy
(18e arr.), 1911

To stay informed about upcoming TASCHEN titles, please request our magazine at www.taschen.com/magazine or write to TASCHEN, Hohenzollernring 53, D–50672 Cologne, Germany, contact@taschen.com, Fax: +49-221-254919. We will be happy to send you a free copy of our magazine which is filled with information about all of our books.

© 2001
TASCHEN GmbH
Hohenzollernring 53, D–50672 Köln
www.taschen.com

Edited by
 Hans Christian Adam, Göttingen in collaboration with Ute Kieseyer, Cologne

Design
 Lambert und Lambert, Düsseldorf
Cover design
 Angelika Taschen, Cologne
Production
 Horst Neuzner, Cologne

Text editing and layout
 Ute Kieseyer, Cologne
French translation
 Catherine Henry, Nancy
English translation
 Malcom Green, Heidelberg

Printed in Italy
ISBN 978-3-8228-5549-2

Photo Icons Vol. 1
Hans-Michael Koetzle / Flexi-cover,
Icons, 192 pp. / € 6.99 /
$ 9.99 / £ 4.99 / ¥ 1.500

Photo Icons Vol. 2
Hans-Michael Koetzle / Flexi-cover,
Icons, 192 pp. / € 6.99 /
$ 9.99 / £ 4.99 / ¥ 1.500

"These books are beautiful objects, well-designed and lucid." —*Le Monde*, Paris, on the ICONS series

"Buy them all and add some pleasure to your life."

African Style
Ed. Angelika Taschen

Alchemy & Mysticism
Alexander Roob

American Indian
Dr. Sonja Schierle

Angels
Gilles Néret

Architecture Now!
Ed. Philip Jodidio

Art Now
Eds. Burkhard Riemschneider,
Uta Grosenick

Atget's Paris
Ed. Hans Christian Adam

Audrey Hepburn
Ed. Paul Duncan

Bamboo Style
Ed. Angelika Taschen

Berlin Style
Ed. Angelika Taschen

Brussels Style
Ed. Angelika Taschen

Cars of the 50s
Ed. Jim Heimann, Tony Thacker

Cars of the 60s
Ed. Jim Heimann, Tony Thacker

Cars of the 70s
Ed. Jim Heimann, Tony Thacker

Chairs
Eds. Charlotte & Peter Fiell

Charlie Chaplin
Ed. Paul Duncan

China Style
Ed. Angelika Taschen

Christmas
Ed. Jim Heimann, Steven Heller

Classic Rock Covers
Ed. Michael Ochs

Clint Eastwood
Ed. Paul Duncan

Design Handbook
Eds. Charlotte & Peter Fiell

Design of the 20th Century
Eds. Charlotte & Peter Fiell

Design for the 21st Century
Eds. Charlotte & Peter Fiell

Devils
Gilles Néret

Digital Beauties
Ed. Julius Wiedemann

Robert Doisneau
Ed. Jean-Claude Gautrand

East German Design
Ralf Ulrich / Photos: Ernst Hedler

Egypt Style
Ed. Angelika Taschen

Encyclopaedia Anatomica
Ed. Museo La Specola Florence

M.C. Escher

Fashion
Ed. The Kyoto Costume Institute

Fashion Now!
Eds. Terry Jones, Susie Rushton

Fruit
Ed. George Brookshaw,
Uta Pellgrü-Gagel

HR Giger
HR Giger

Grand Tour
Harry Seidler

Graphic Design
Eds. Charlotte & Peter Fiell

Greece Style
Ed. Angelika Taschen

Halloween
Ed. Jim Heimann, Steven Heller

Havana Style
Ed. Angelika Taschen

Homo Art
Gilles Néret

Hot Rods
Ed. Coco Shinomiya, Tony
Thacker

Hula
Ed. Jim Heimann

Indian Style
Ed. Angelika Taschen

India Bazaar
Samantha Harrison, Bari Kumar

Industrial Design
Eds. Charlotte & Peter Fiell

Japanese Beauties
Ed. Alex Gross

Las Vegas
Ed. Jim Heimann,
W. R. Wilkerson III

London Style
Ed. Angelika Taschen

Marilyn Monroe
Ed. Paul Duncan

Marlon Brando
Ed. Paul Duncan

Mexico Style
Ed. Angelika Taschen

Miami Style
Ed. Angelika Taschen

Minimal Style
Ed. Angelika Taschen

Morocco Style
Ed. Angelika Taschen

New York Style
Ed. Angelika Taschen

Orson Welles
Ed. Paul Duncan

Paris Style
Ed. Angelika Taschen

Penguin
Frans Lanting

20th Century Photography
Museum Ludwig Cologne

Photo Icons I
Hans-Michael Koetzle

Photo Icons II
Hans-Michael Koetzle

Pierre et Gilles
Eric Troncy

Provence Style
Ed. Angelika Taschen

Robots & Spaceships
Ed. Teruhisa Kitahara

Safari Style
Ed. Angelika Taschen

Seaside Style
Ed. Angelika Taschen

Signs
Ed. Julius Wiedeman

South African Style
Ed. Angelika Taschen

Starck
Philippe Starck

Surfing
Ed. Jim Heimann

Sweden Style
Ed. Angelika Taschen

Sydney Style
Ed. Angelika Taschen

Tattoos
Ed. Henk Schiffmacher

Tiffany
Jacob Baal-Teshuva

Tiki Style
Sven Kirsten

Tokyo Style
Ed. Angelika Taschen

Tuscany Style
Ed. Angelika Taschen

Valentines
Ed. Jim Heimann,
Steven Heller

Web Design: Best Studios
Ed. Julius Wiedemann

Web Design: E-Commerce
Ed. Julius Wiedemann

Web Design: Flash Sites
Ed. Julius Wiedemann

Web Design: Music Sites
Ed. Julius Wiedemann

Web Design: Portfolios
Ed. Julius Wiedemann

**Women Artists
in the 20th and 21st Century**
Ed. Uta Grosenick

70s Fashion
Ed. Jim Heimann

ICONS